TWILIGHT TOGETHER

TWILIGHT TOGETHER

PORTRAITS OF IRELAND AT HOME

RUTH MEDJBER

doubleday
IRELAND

TRANSWORLD IRELAND
Penguin Random House Ireland, Morrison Chambers, 32 Nassau Street, Dublin 2, Ireland
www.transworldireland.ie

Transworld Ireland is part of the Penguin Random House group of companies
whose addresses can be found at global.penguinrandomhouse.com

First published in Great Britain in 2020 by Doubleday Ireland
an imprint of Transworld Publishers

A CIP catalogue record for this book is available from the British Library.

ISBN 9781781620571

Design by Julia Lloyd
Printed in Italy by Printer Trento Srl

Penguin Random House is committed to a sustainable
future for our business, our readers and our planet. This book
is made from Forest Stewardship Council® certified paper.

1 2 3 4 5 6 7 8 9 10

To B. Q.

Without you, I'm nothing

x

F O R E W O R D

There is a power and potency that arises when women gather, when women lead, when women protect and when women create. Women as societal leaders and parity within traditional relationships have, I believe, been quietly negotiated in communities and individual homes across all four provinces of our island during the Covid-19 pandemic. I look for and to the caregivers in my life as I navigate the fallout of Covid. Our war heroes in this battle are distinctly female. My eyes are transfixed on the people capable of helping me understand the world we now inhabit. The stillness that came during lockdown has gifted many of us time to re-evaluate who we are and whom we love. It is these very moments of quietness, shelter and solidarity that Ruth has captured in *Twilight Together*. We are living in a time when nothing is certain. Lives are on the line. And, as a result, anything is possible. The system is being redefined. We have become smaller individually but more powerful collectively. Ruth has embraced the uncertainty born from this worldwide pandemic. As a female photographer, she has grasped the fear that has broken us down and cracked our worlds apart. The realization that the world is a better place when we are open and vulnerable is at the core of this powerful book of photography.

Writing is hard, even for authors who do it all the time. Words are not my traditional palette. As an artist, I reach for a pencil and paper. I have an

underlying unease with words. Their meaning can be misconstrued. My first language is the visual. Like Ruth, I use it to decipher and discuss events and situations this world chaotically throws at us. The public engages in creative activities to get through isolation, but they also rely on us artists to document and navigate this crisis for them. Someone once told me, as I sat at the edge of a forest rave, that in life 'we are just all walking each other home'. The significance of this throwaway comment has stayed with me for close to half my life. I understand it as a metaphor for the collective. I reflect on it when I am at my very best and go to it when I am at my very worst. In this book, Ruth has walked us all home.

Both you and I are found in each of these windows. Our anxiety is somehow eased, knowing we are all in this moment together. We are framed in windows that are single-paned, freshly washed, double-glazed, ash-framed, stone-framed, leaded, web-laced, encircled in plant growth, or just above the waterline. Yes, we have been distanced, but the ambiguity and half-light of twilight has provided warm glimpses of togetherness. We are that flamboyant guest.

On Wednesday, 27 May, Ruth left her Dublin home to photograph me and my neighbours in Tullamore, Co. Offaly in the gloaming. In the days leading up to her visit, I spoke to four of them about Ruth, her previous work, this project and the possibility of their involvement. Instantly it became a social event in a time almost barren of jovial interaction. This beautifully thought-out venture brought a connection that was so deeply missing.

My road came to life as we shouted to one another up driveways, through letterboxes and across lawns. Adults became skittish and kids ran to switch on every light in the house. Smiles graced faces once more, and the meaning of 'home' and 'love' came to the fore of everything. That is the power of art, and of Ruth's photography, all captured here as a simple and powerful reminder of what matters most.

Joe Caslin, July 2020

INTRODUCTION

Before Covid-19 I was working as a successful music photographer. I was travelling around the world with bands and musicians, living on tour buses. Night after night I would photograph them performing live on stage.

I have always been a photographer. I started mimicking my father with his camera when I was a toddler, and never quite got over my obsession with hearing the click of the shutter. I combined photography with my love of music when I was a teenager, and from there my career began.

When I was first starting out I shot each and every band at every tiny, sweaty venue that would have me. I said yes to any job that was offered. It wasn't an easy or a straightforward path, but it was all I ever wanted to do, so I persevered. I spent years building my network, my skill set and my reputation. I worked for music magazines such as *Hot Press* and *NME*, and in 2018 I held a retrospective exhibition of my music photography, which was a major moment in my career. I was earning a living doing what I loved, and I was extremely grateful and proud.

In early 2020 I was looking ahead to a full year of work and gigs. My summer plans revolved around photographing music festivals, including my favourite week of the year: Glastonbury. I was due to exhibit my work in Sydney, Australia, and then hop on a tour around the US. In early March my inbox began to fill

up with cancellations. Festivals, exhibitions, tours — all gone. I found myself at a complete loss. My career and livelihood had been put on pause, with no sign of a restart date, and I was heartbroken.

Not even two weeks into lockdown and I was bored, restless and missing people. It had begun to affect my mental health. I realized just how integral photography is to my very being. My life is centred around photographing people, and without a camera in my hand I was lost.

My career and lifestyle had also conditioned me to be a nocturnal person. Usually, my whole day would be leading up to the night. A band would walk onstage at 9 p.m. and I'd be right there with them. The adrenalin rush from the show — hearing the screams of thousands of fans and watching your friends lose themselves in their live performance — is an amazing feeling. I'd shoot for the next few hours and then edit until dawn. It was a nightly routine that I adored.

Sitting at home during lockdown, alone with the dog, I'd begin to get antsy at around 8 p.m. My body clock was still set to a touring schedule. I'd look out of my living-room window and notice the lights coming on around the estate courtyard. The magic of twilight has always enticed me — the last traces of sunlight mixing with the silver glimmer of the moonlight is by far my favourite time to take photos.

I began by contacting friends who lived within walking distance of my home. I kept the instructions fairly simple: turn on all the lights in the front room of the house, put a lamp on the windowsill (and if they didn't have one I'd bring a spare one with me), open the curtains wide, and come to the window at twilight. The shoot wouldn't take more than five minutes, and I never interfered with anything — everybody chose what they wore and how they stood. They had control over their own portrait and how they wanted to be seen. Even on that first night, I knew I was capturing something special.

I began the project to ease my loneliness. Living by yourself in lockdown might seem like a dream for people in cramped house-shares, or for those

with young, energetic kids, but I can assure you that the grass is always greener, and living alone during that time had its drawbacks. The lack of human interaction was a serious downer. Days would pass without me seeing a single soul. Phone calls didn't quite cut it, and there were only so many group video chats you could do with couples and families before getting insanely jealous whenever they'd hug or even sit close together on the couch. *Grá sa Bhaile*, the original name of this project, was the answer to my isolation, my excuse to visit people and my way of satisfying my passion for photography.

When I published the first sixteen photos online, the response from the public was unbelievable. It seemed that I wasn't the only person looking for that connection. In capturing images of healthcare workers, new parents, people self-isolating, cocooners and empty nests that were suddenly full once more, I was capturing the wider story of Ireland under lockdown. People loved knowing that everybody else was at home too, going through the same things that they

were. I decided to continue the project on a larger scale and I began to travel across the country.

The 150 homes featured in this book are from all over Ireland. I visited the biggest cities and the smallest, rural villages. There are castle gatehouses, city-centre apartments, mansions and tiny cabins – there's even a boat. My selection process was minimal and inclusive. I'd pick an area to visit based on one person that I knew there – a friend, or someone I was told had an interesting lockdown story. Once I'd chosen an area for the night, I'd check my emails to see who could be added to my route and I'd put them on the list.

Some nights I'd shoot ten houses, other nights I'd manage just one. Twilight only lasts between thirty and forty minutes, so I'd always run out of time. Rural areas were particularly difficult to cover because of the greater distances between homes. By the end of lockdown, there were close to 600 emails still to be answered. This book was shot over the course of three months, but I could easily have carried on for three more years. Thankfully, lockdown didn't last that long.

Twilight Together is the silver lining of my lockdown and the saving grace of my sanity. It will serve as a reminder that when I'm faced with a fight-or-flight situation, I'll always fight. The lockdown took a lot from us, each in different ways. Hopefully, this book will remind us what it also gave to us. It gave us a chance to slow down and take stock. To figure out what is really important in our lives. It gave us a new perspective and an appreciation of what we have. It gave us time. Time to spend as we wished, with our families, our hobbies. Time to explore our neighbourhoods, to bake, to sing, to decorate. Time to be ourselves. I doubt we'll ever have that gift of time and togetherness again.

Grá, Ruth

TWILIGHT TOGETHER

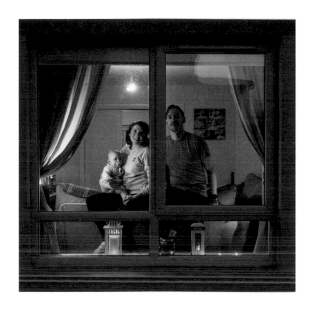

This window was where it all started. I spend a lot of time in this house, with my friends Maeve and Paul, and their baby, Beth (aka Bumble Bee). When I first had the idea to shoot this style of window portrait, I needed to test it out to make sure the vision in my head was achievable. Maeve, forever my cheerleader, kept Bumble Bee up past her bedtime so that it would be dark enough for twilight.

It was 23 March 2020 and just after 8 p.m. when we got the first shots. It was strange being at their house and not being able to go in. Not being able to kiss the baby goodnight, or join my friends on the couch to watch TV and drink tea. I walked away that night not knowing what would come of this project, or when I'd see my friends again.

I knew that the idea had worked, that there was a certain type of magic in these windows at that time of night. However, I could never have imagined the journey I'd go on, the people I'd meet, or that I would spend nearly every single night of the following sixteen weeks standing in front of people's windows and looking in.

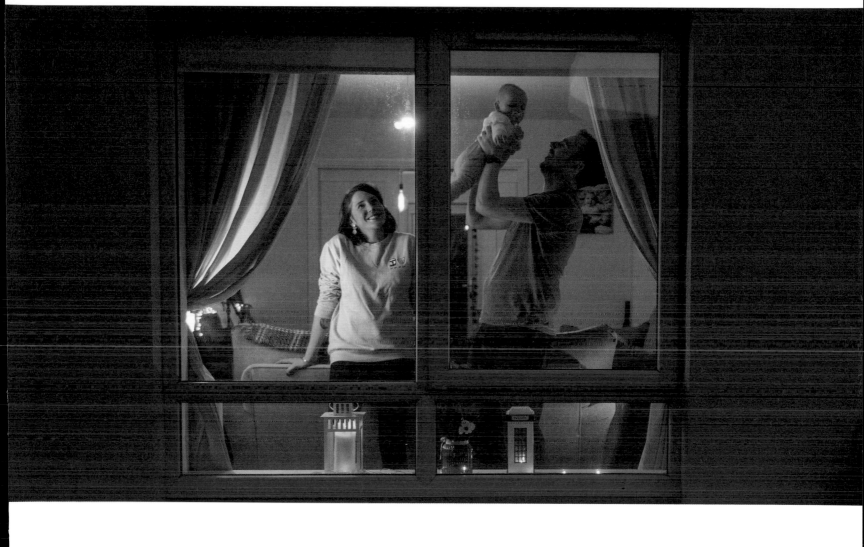

My parents, Mohamed and Tina Medjber, are far from cocooning age, but I still wanted to help them minimize the time they had to spend in crowded shops. So, for the first couple of months of lockdown, I did all of their shopping for them. Anything they needed, they were to call me and I'd go and grab it for them, without fuss or hesitation.

The socially distanced queues in shopping centres stretched out of the doors. I would join them, with my mask on and my list in my hand. The trolleys were assigned outside and only one person per household was allowed in. It was like a military operation. After being disinfected at the door, and with a nod from the security guard, it was my time to shine. I would bounce around the aisles in record time, trying to decipher my mam's handwriting, and would make sure to add extra treats that they might like but wouldn't think of asking for. Anything to make the isolation easier for them.

When I pulled into their drive, I'd beep the car horn so that they'd open the front door (one less thing for me to sanitize afterwards). One day, as I dropped the bags of shopping on the step, having carefully wiped them down, I noticed that Dad had his coat and shoes on.

'Have you been out?' I asked.

'Yes, just popped down to the shops to do the lotto.'

Give me strength.

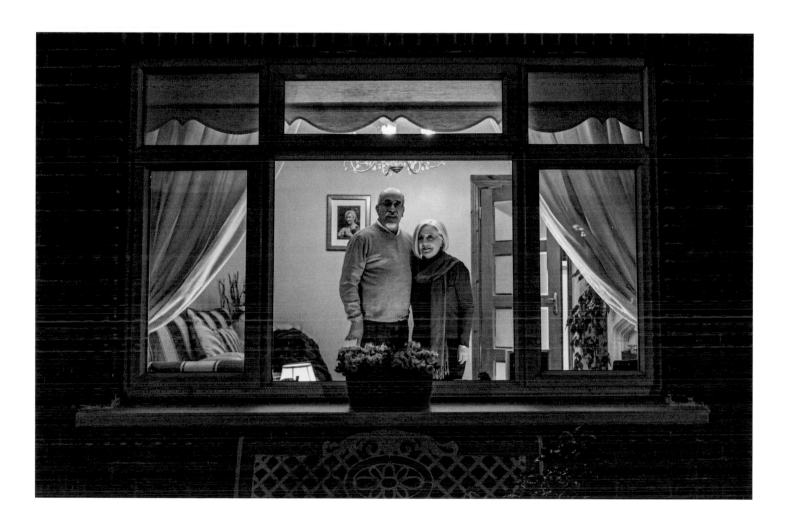

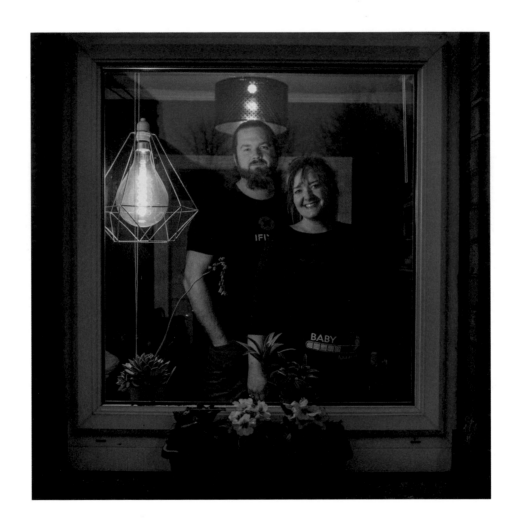

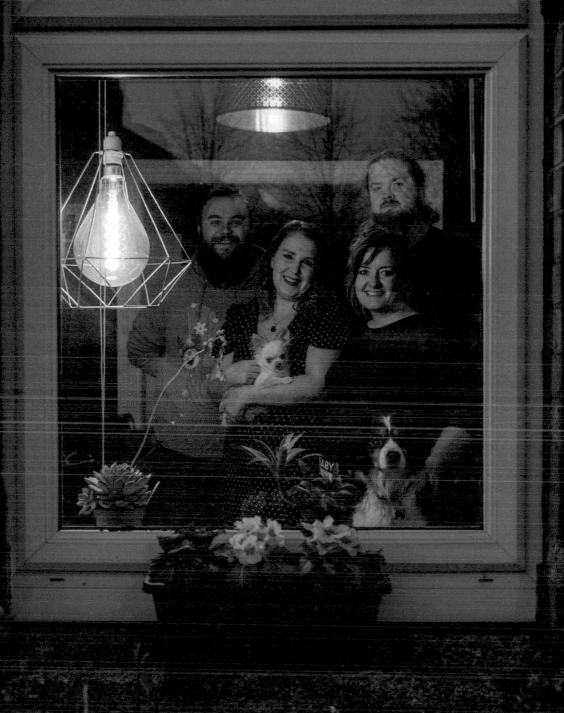

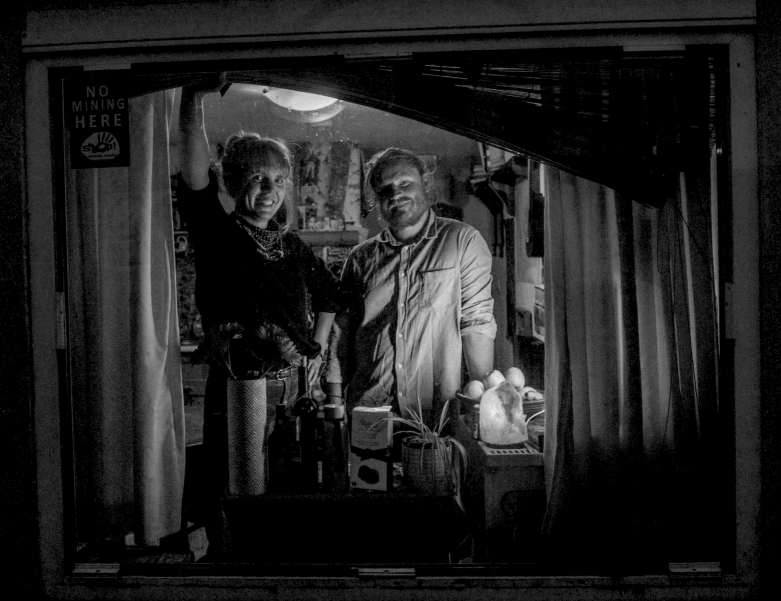

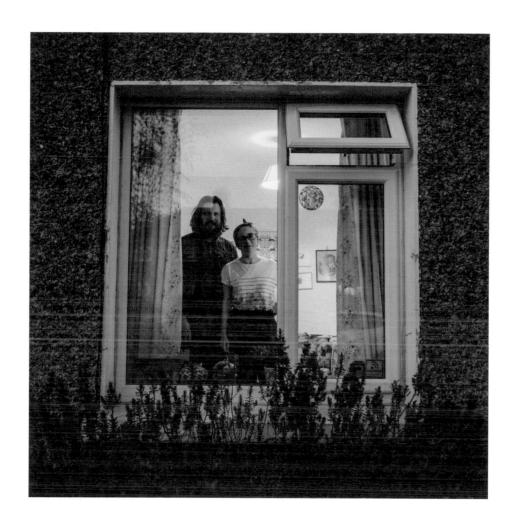

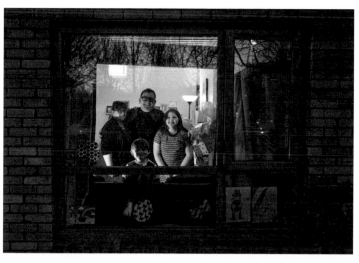

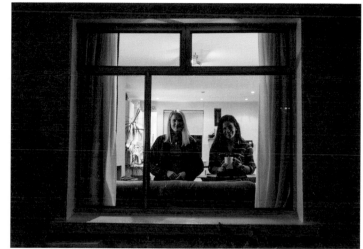

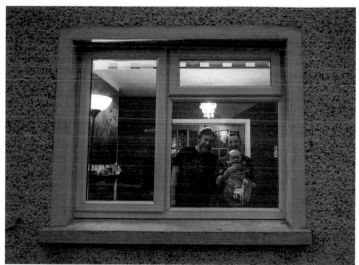

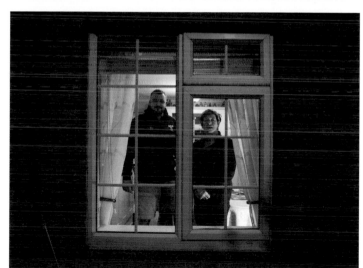

Una is an accomplished artist and John proudly showed me some of her finest paintings. However, it was John who knew exactly how he'd like this photo composed. When I arrived, the chair was in place already and the lighting was set just right.

'I'm going to sit here, like this, and Una will have her hand on my shoulder, just like they did in those old Victorian photos.'

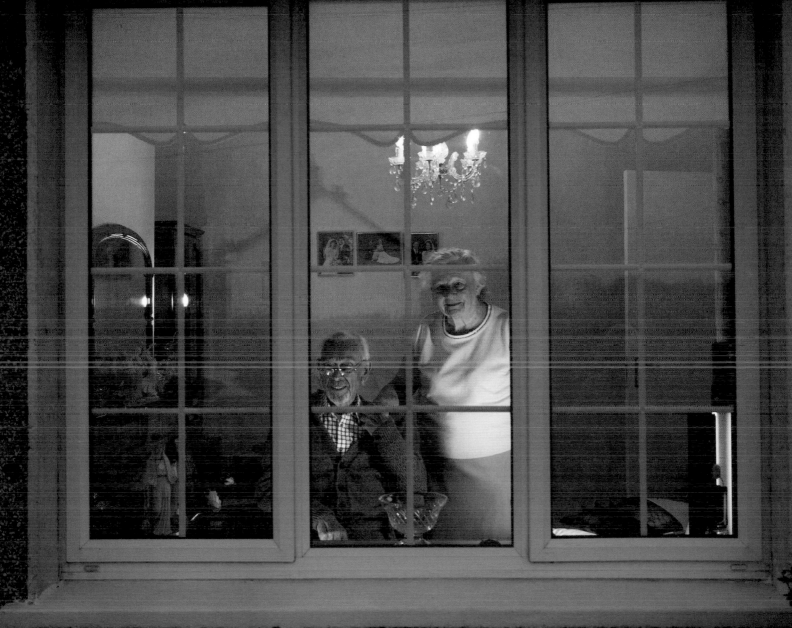

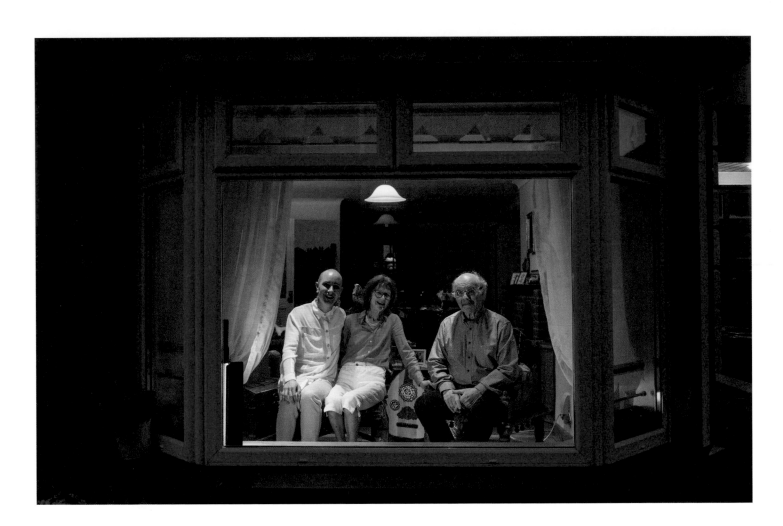

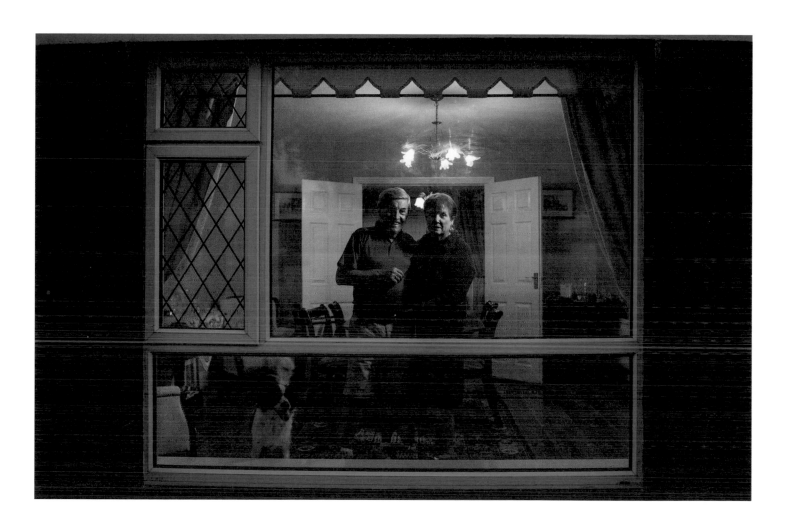

The night I took this photo, Mick and Kim were supposed to be getting married. Instead, they raised a glass with their families and friends on Zoom (and Leonard the cat).

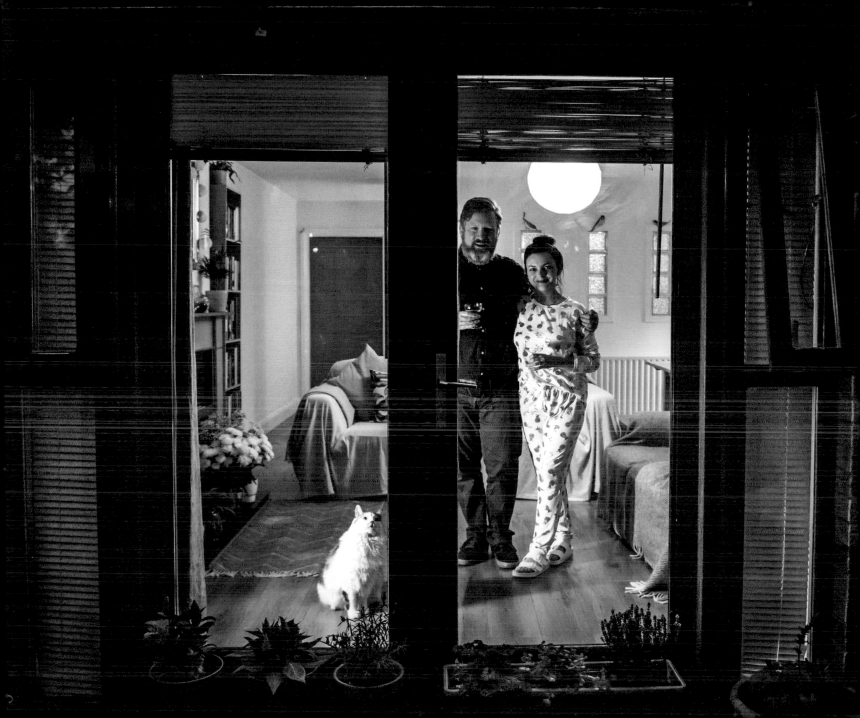

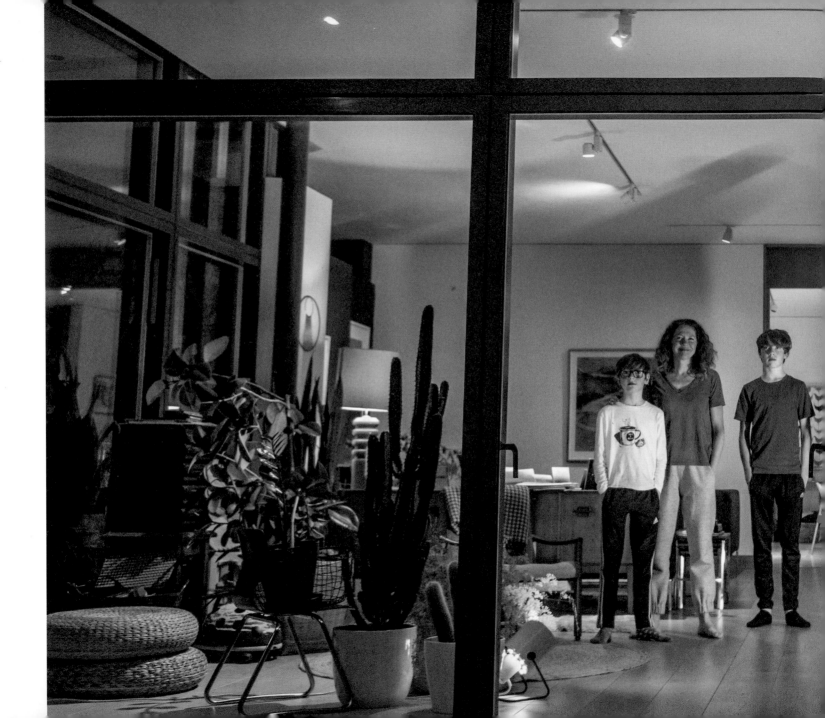

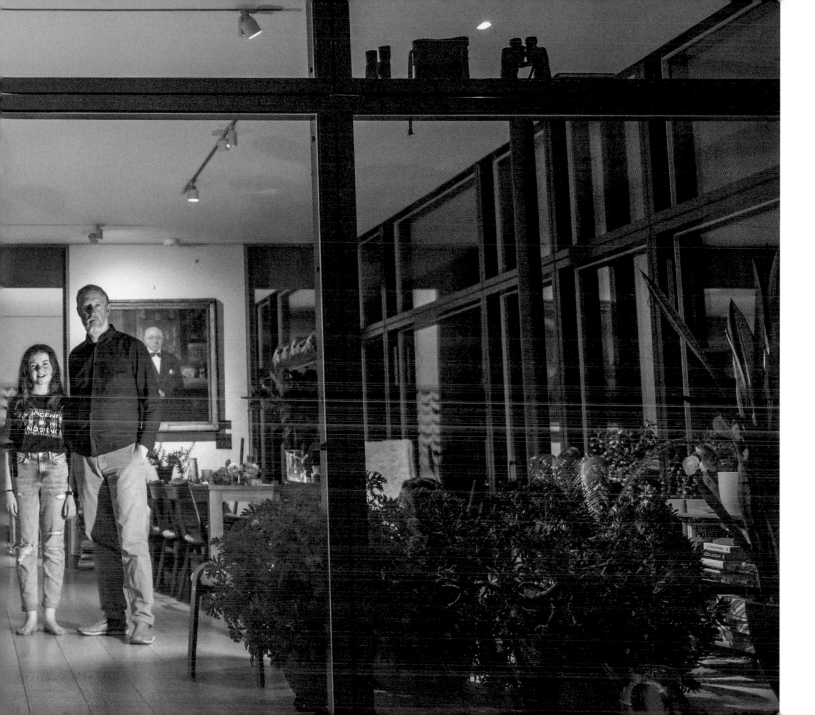

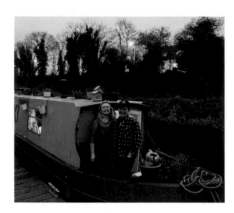

I visited my friends Claire and Ais on their houseboat the night the Taoiseach, Leo Varadkar, announced the 2 km travel restrictions. I suspected it was coming, so I wanted to make sure I saw them while I could (albeit from a safe distance). I worried about what life on their boat might be like for them – if they would have enough provisions and sufficient space for both of them to work from home…

It turns out I had nothing to worry about. When the public began to walk and gather on the scenic riverside where they were moored, Claire and Ais would simply untie their boat and move on to somewhere quieter. And when the 5 km rule came in, they changed location again. And again. A new view to wake up to each time. By the end of lockdown they were halfway across Ireland.

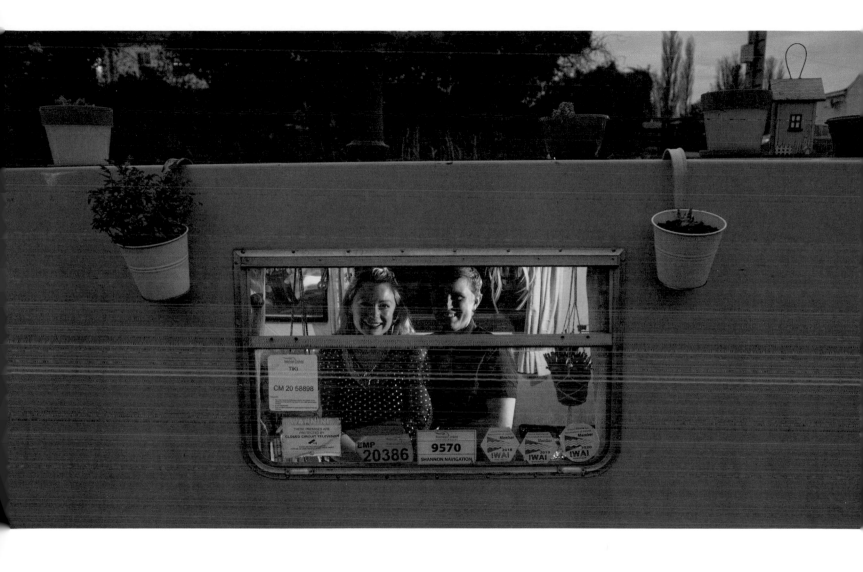

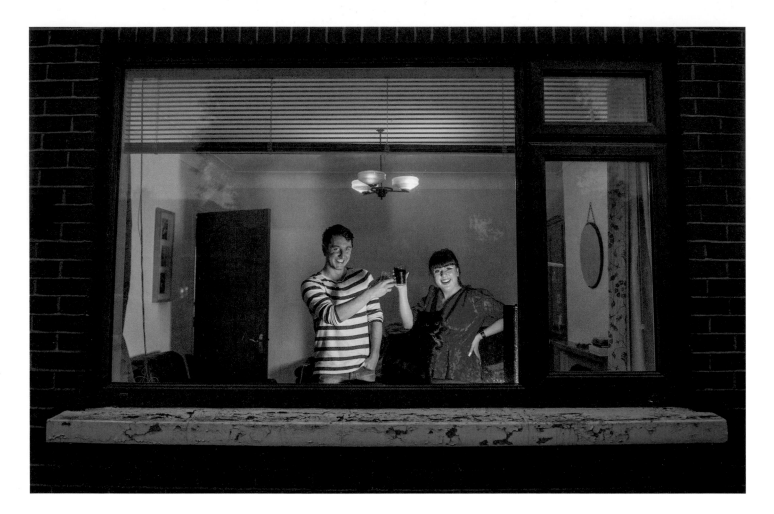

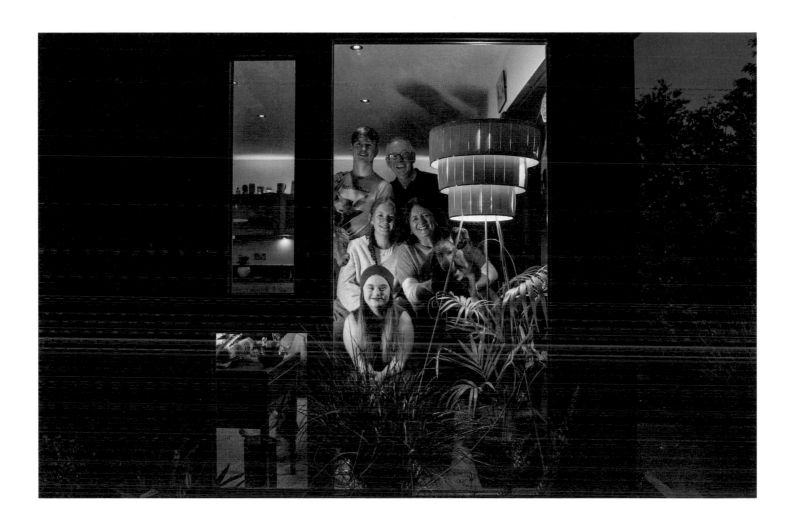

Rocky and Zonja DJ'd their way through lockdown. They set up a mini-studio in their front room and broadcast music and the craic far and wide. I'm used to watching their DJ sets at festivals and in clubs, so it was a beautiful jolt of nostalgia to join them via a live stream.

When I popped over to their home for their portrait, they were sitting down to 'Quarantinis', having just put their kids to bed. I'm not going to lie, I nearly burst through the door to join them.

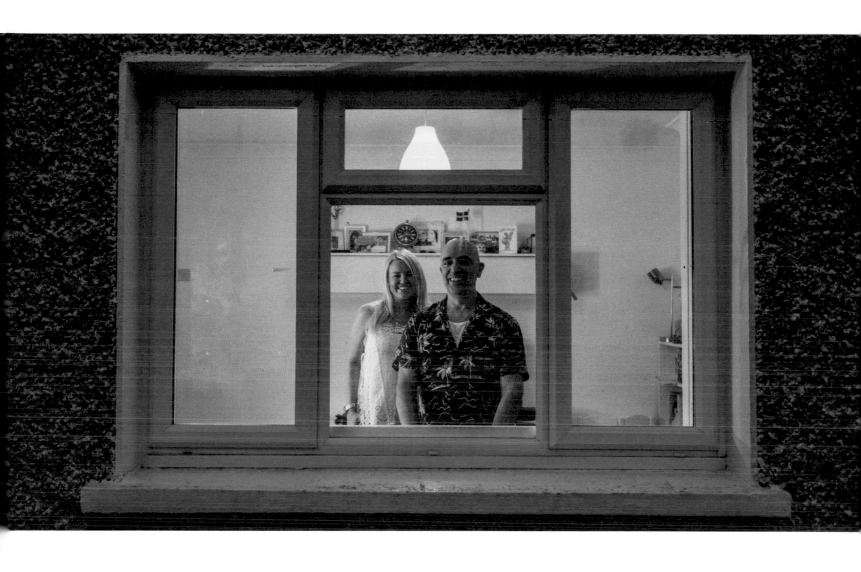

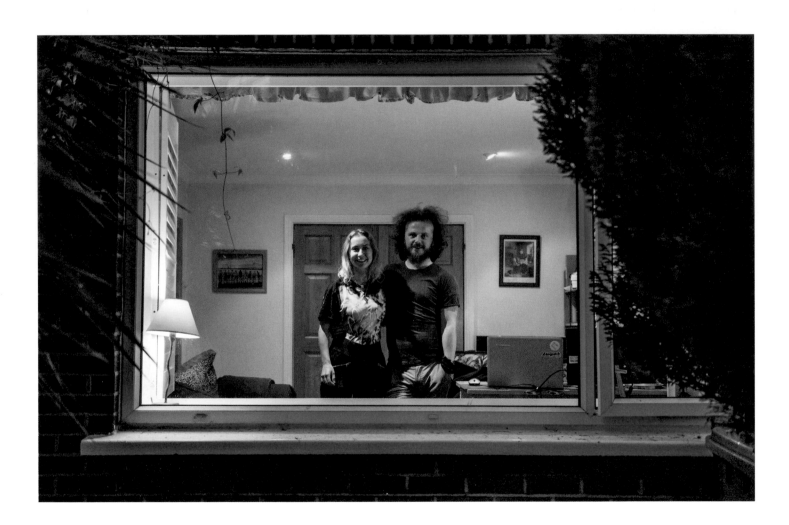

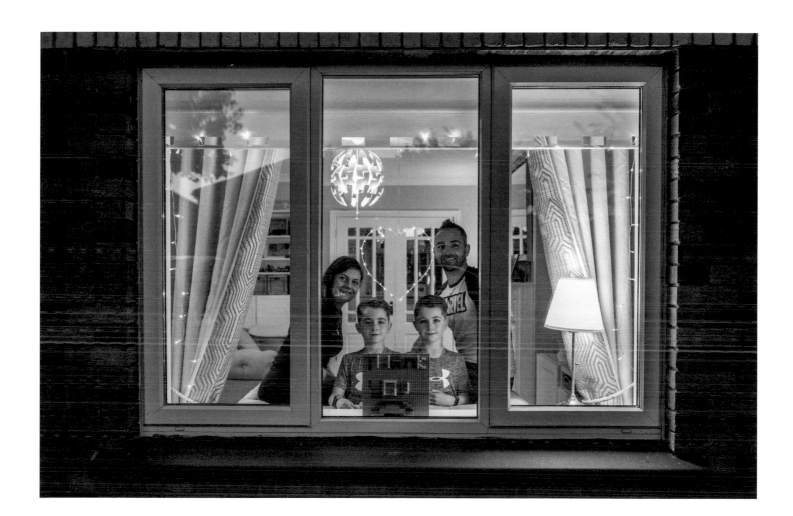

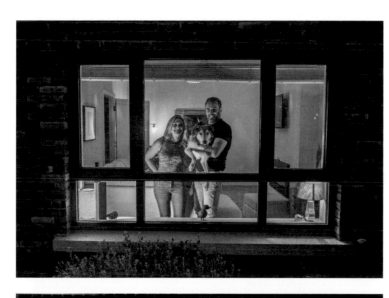
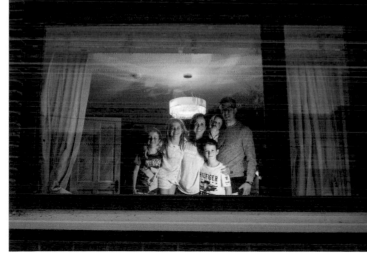

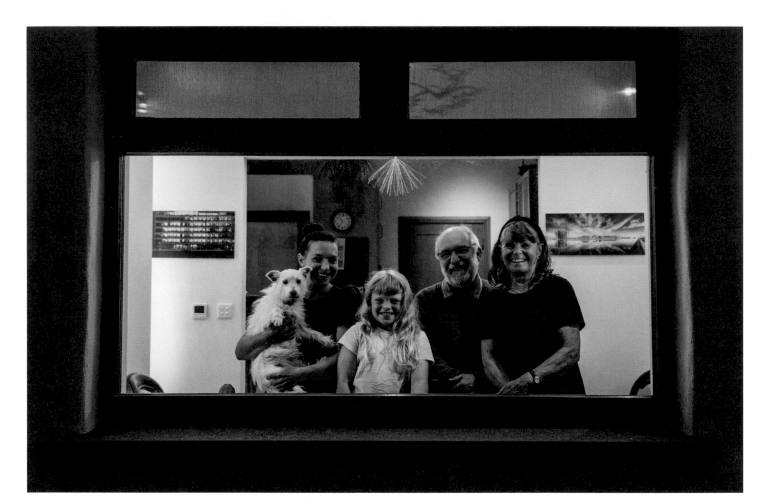

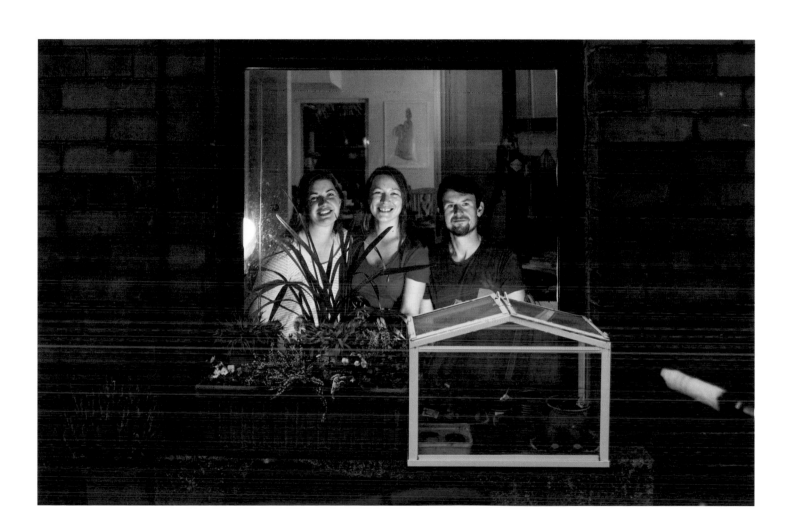

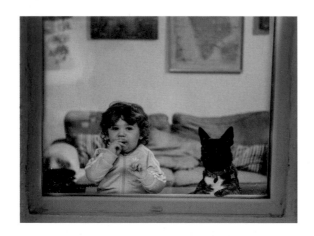

Like everyone, I missed my hairdresser more than I ever thought possible. When I showed up to photograph Dearan, his wife, Tash, their son, Linus, and his best pal, Avon Barksdale, I was tempted to arrive at his window with a pair of scissors and just beg him until he agreed to trim my fringe.

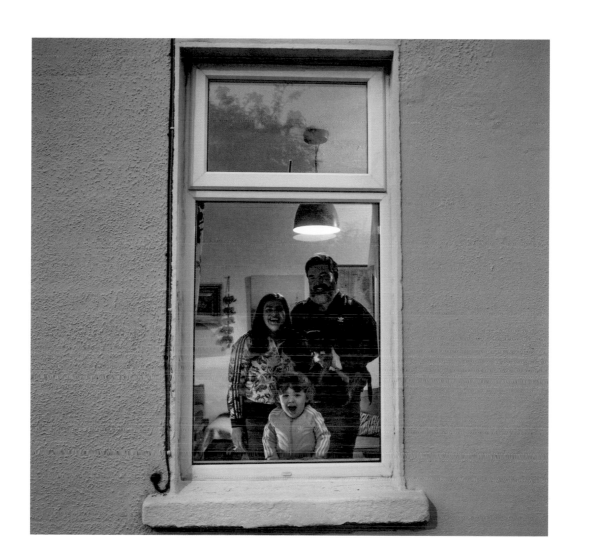

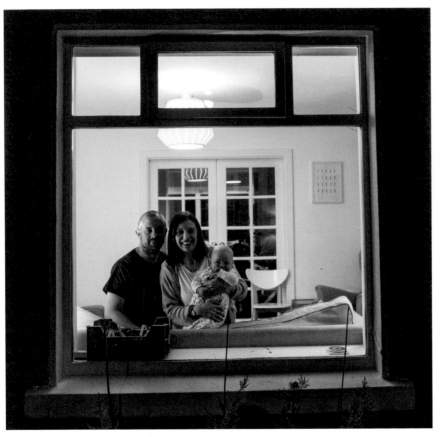
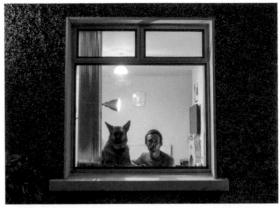
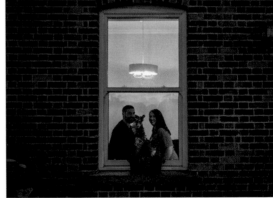

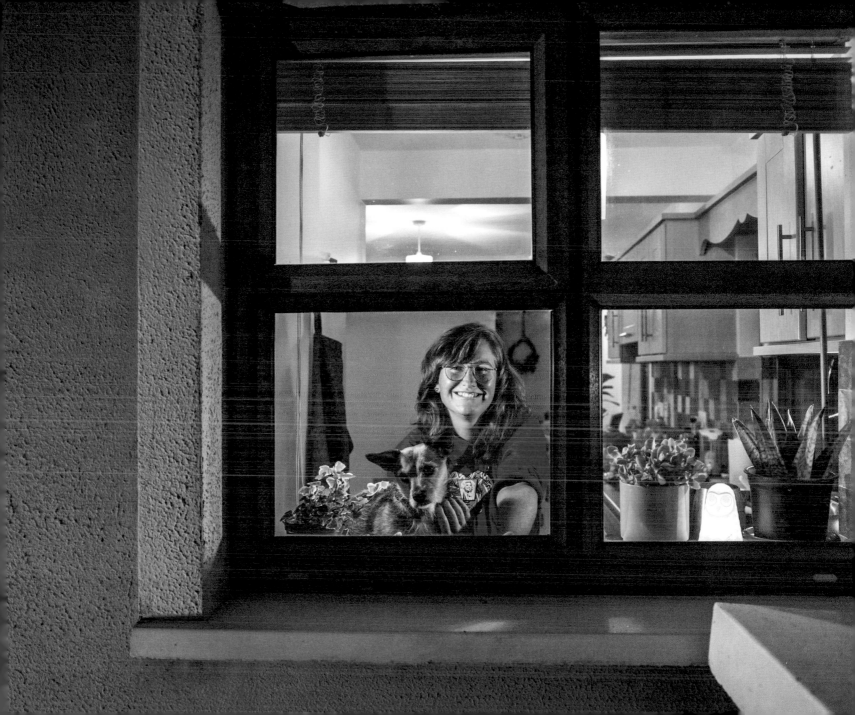

My friends John and Dena had just moved to within 2 km of my home as lockdown started. Dena was a few weeks away from her due date, and we planned to do a shoot while she was still pregnant. We all thought that lockdown would be long over by the time the baby arrived, but joked that if it was still going on, we could recreate the shot with the three of them.

A month or so later a message arrived: 'Baby Elliot is ready for his lockdown portrait'.

So many babies were born into this strange time. The restrictions in hospitals meant that visitors were asked to stay away, and even John had to leave Dena and their son shortly after the birth. He was only allowed to return a few days later to collect them.

My heart went out to all these young families, deprived of their first few days together, having to make do with video calls and photos. The babies, thankfully, remain blissfully unaware of what all the fuss was about.

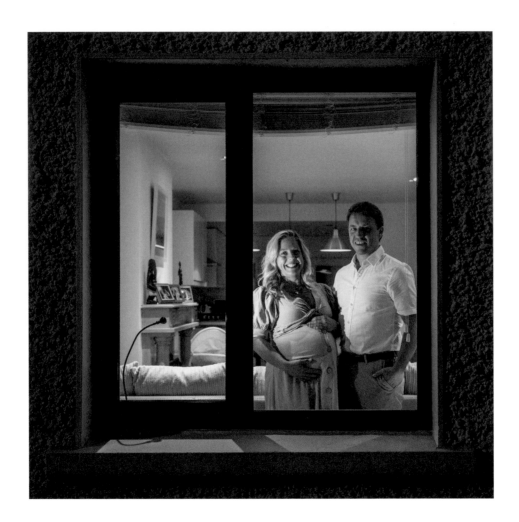

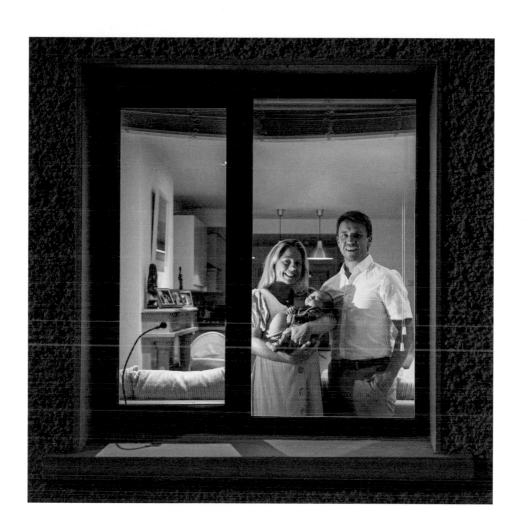

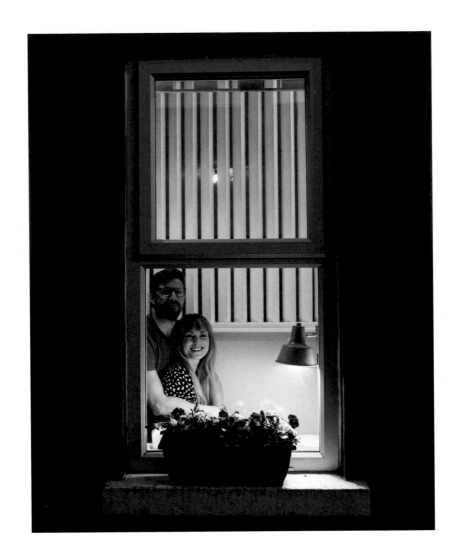

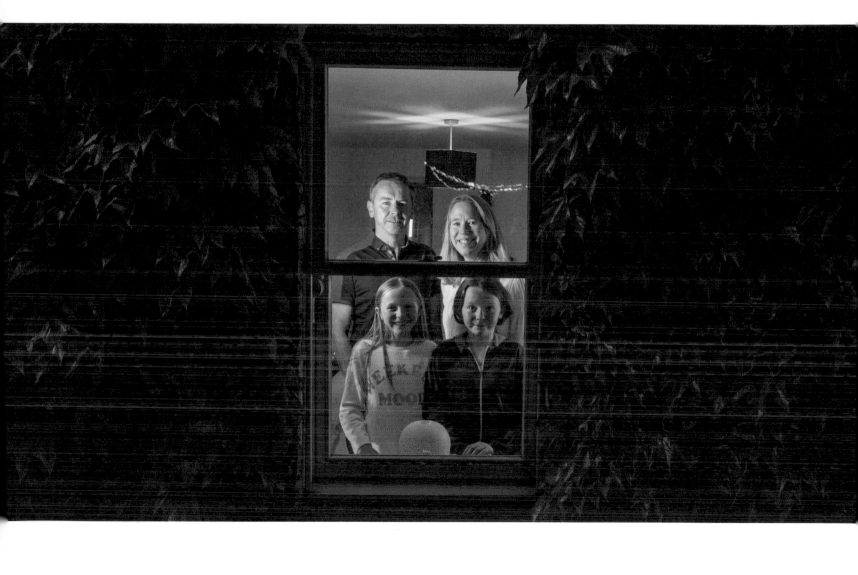

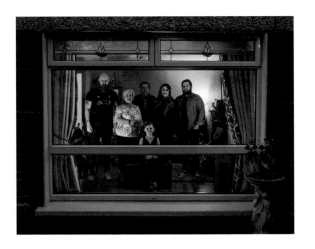

A lot of the time, when I'd arrive at a window, there would be a sense of giddiness inside the house. People would be wearing heels, they'd have dug out their best jeans, or spent time doing their hair properly. They might even have opened a bottle of bubbly. They'd be sitting in the front room with the big light on, blinds pulled up, ready to go as soon as they caught sight of me coming up the drive. 'This is the most excitement we've had in months,' they'd say as they crowded around the open window to chat to me.

When I arrived at the Pope family's house, I didn't have to look for the number on the door. I spotted Riley straight away, excitedly awaiting my arrival, just as you see her here.

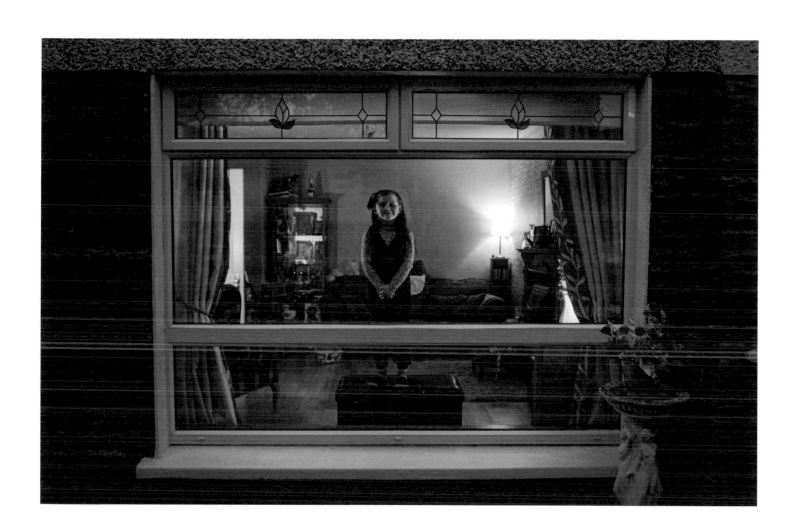

In 2019 I reached a high point in my career as a music photographer. I got to tour with some amazing people and visit some unbelievable places, all while carrying a camera and doing the job I love. I'm incredibly aware that wherever I go in my career, I know that strong, smart women have gone before me. They have paved the way in what was once a male-dominated world.

Pictured here are just some of those women (and their families). We worked together on the Hozier tour, and without these women there simply wouldn't be a show. They have the vision to plan it, the confidence to book it, the experience and wisdom to hit the road, and the energy and warmth to make it enjoyable for all.

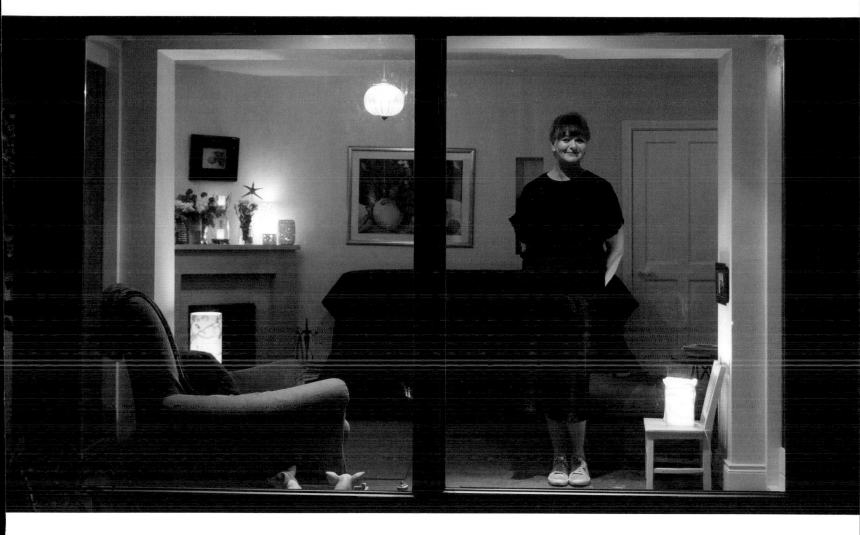

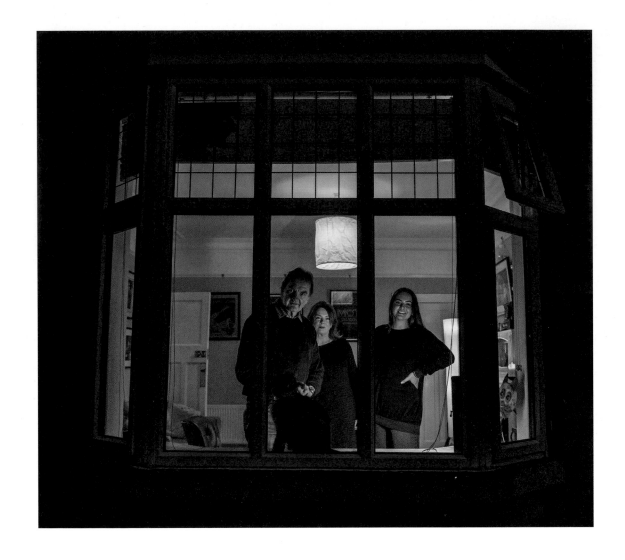

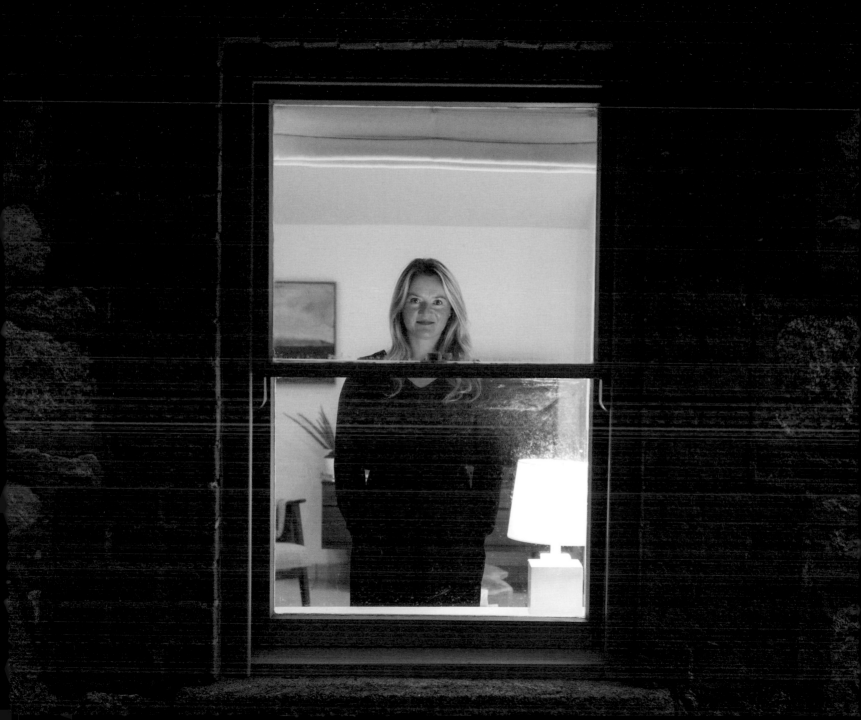

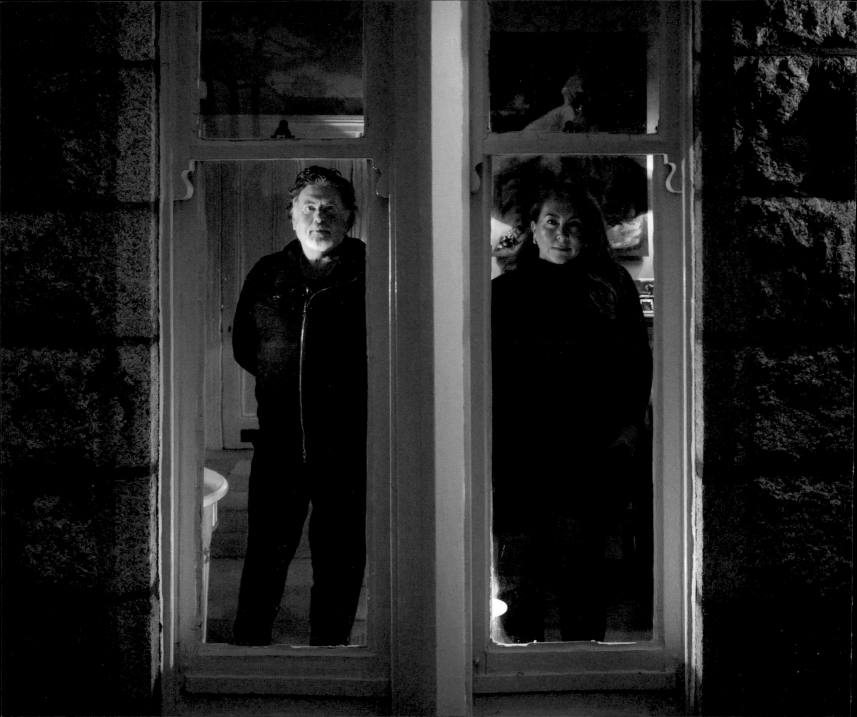

A lot of music professionals are at home now for what will probably be the longest stint of their lives. The music industry was one of the first to be put on pause by the pandemic, and it will be one of the last to get back to normal. Not many people want to spend very long in a crowded, sweaty venue.

I'm one of the lucky roadies. I can turn my hand to photographing other things while I wait for the gigs to return. I can only hope that my friends from the road are as fortunate, and that when our industry does bounce back, it does so better and stronger than ever.

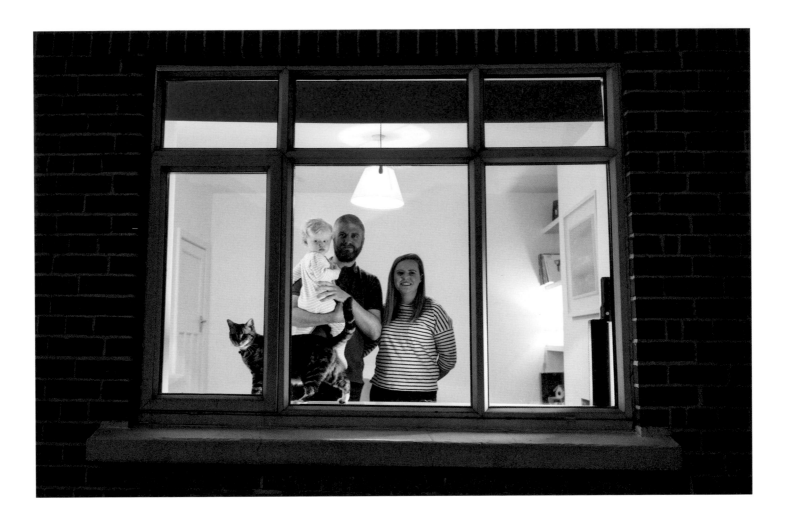

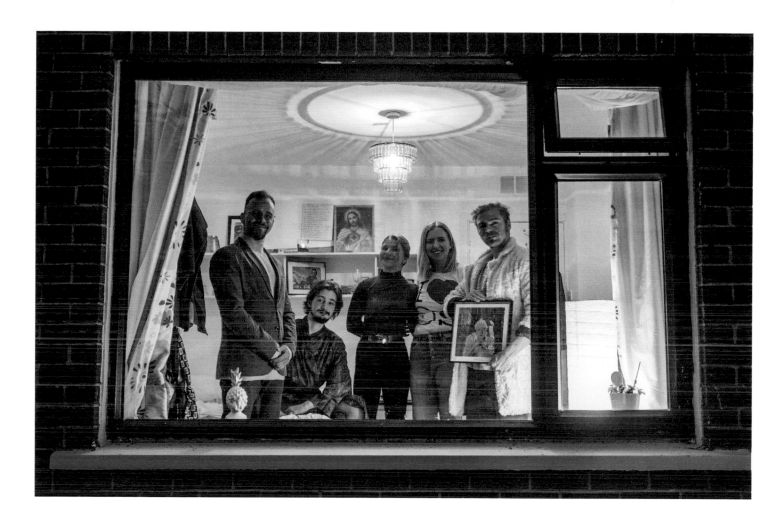

I got to visit my auntie Marie and her husband, Phil, to photograph them at home on their fiftieth wedding anniversary. It wasn't quite the fancy party they had planned, but I was still glad to be invited.

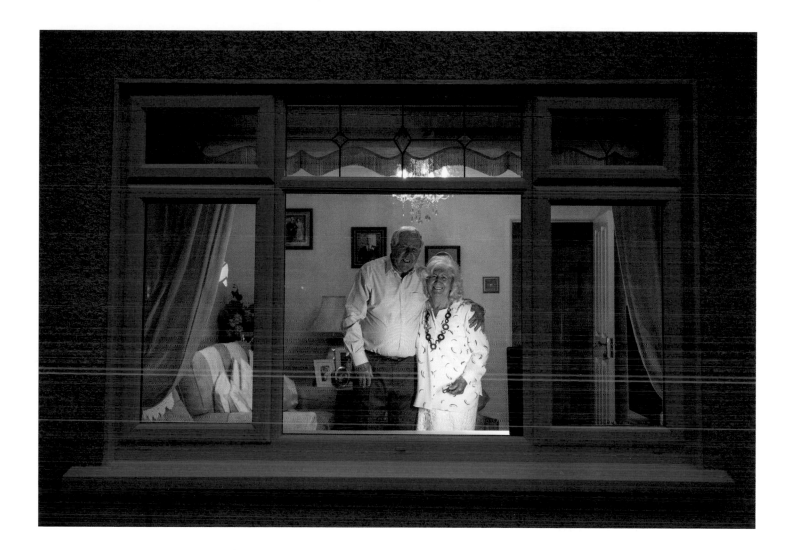

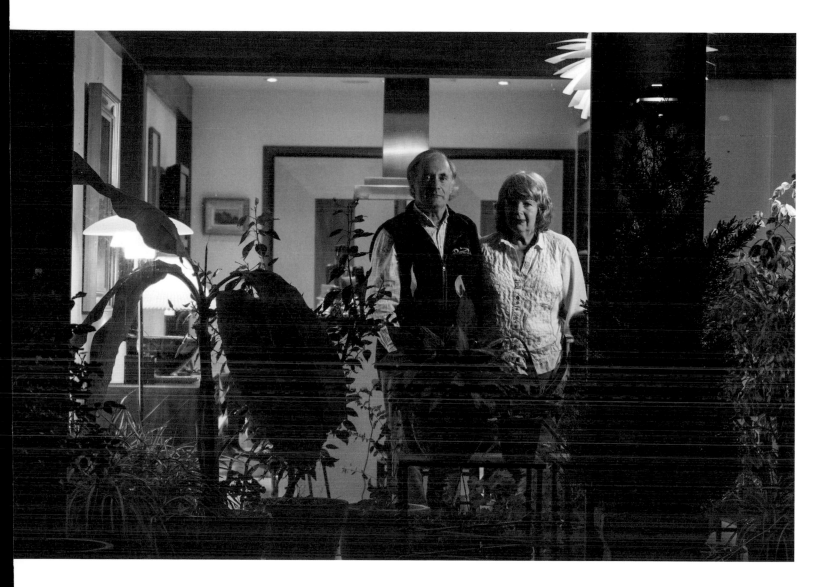

When I arrived down in Kilkenny, Zoë was working away in her sewing room, even though it was close to 10 p.m. A fashion designer by trade, Zoë said she 'responded to the government's call to do whatever it takes to help make people's lives easier during this difficult time', even though that meant her own life was made much harder and she sacrificed spending time with her daughter, Zelda (pictured here snoozing in Zoë's arms).

Each and every day, Zoë sat and sewed facemasks by the hundreds. Like many self-employed people, myself included, she reinvented her business to stay afloat. When you've invested your life in your career, you have no choice but to do everything in your power to survive.

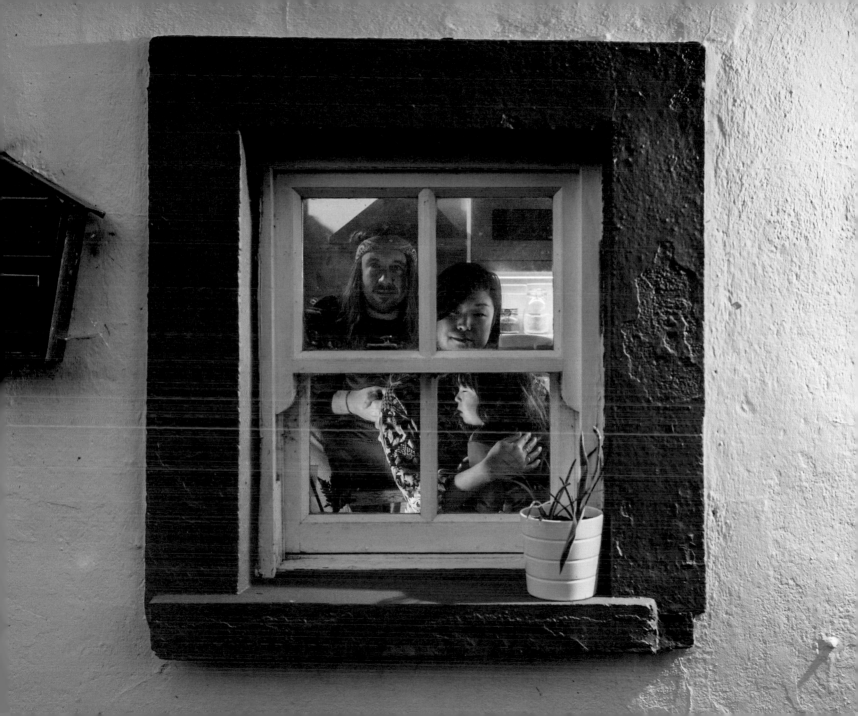

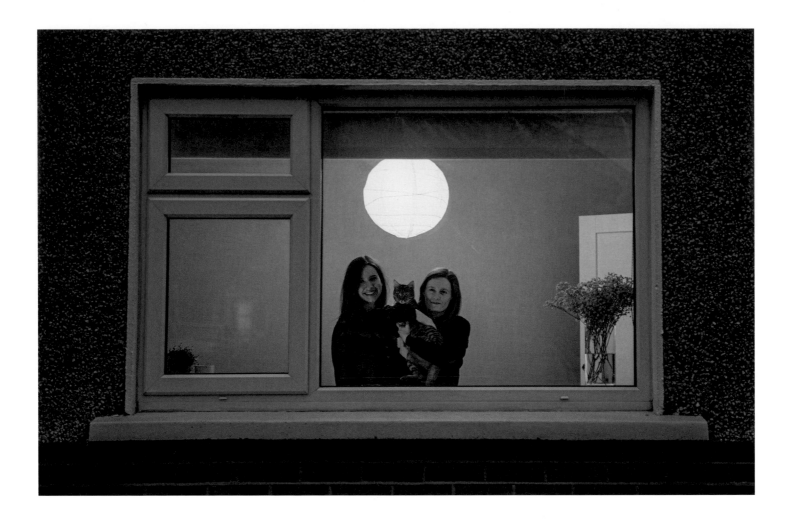

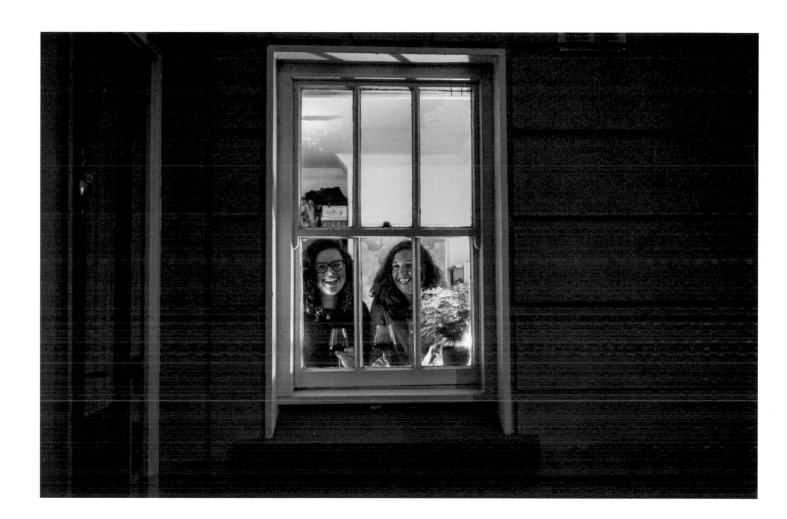

For a lot of people, one of the hardest things about the restrictions on gatherings was losing access to their religious community. Masses were cancelled and churches were closed. Communion dresses went unworn and confirmation money was never collected. But faith didn't stop. People found new ways to pray and come together. Drive-by Masses were one of the more imaginative means by which priests connected with their congregation.

One religious celebration that took place during lockdown was Eid al-Fitr, the end of Ramadan. I was very aware of Ramadan while shooting this project. Conscious that my days were centred around twilight, just like those of Muslims all over the world. As the sun set, their fast would end and they would gather together to eat. Their houses would come alive after dark, much like my own.

I photographed Shohida and her family on Eid al-Fitr. On a night when they would usually visit family and friends, and pray as a community in the local mosque, they stayed home. They decorated the house, put on their best outfits, and celebrated being together.

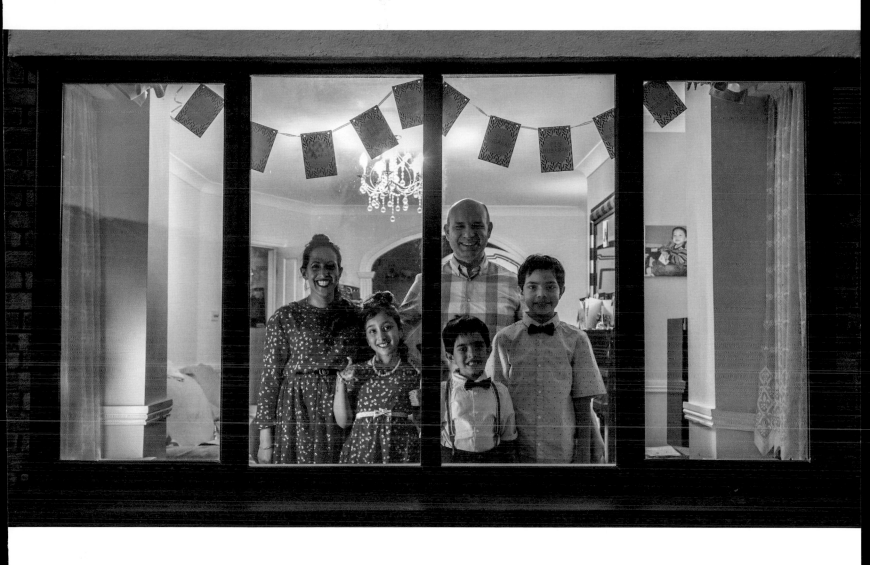

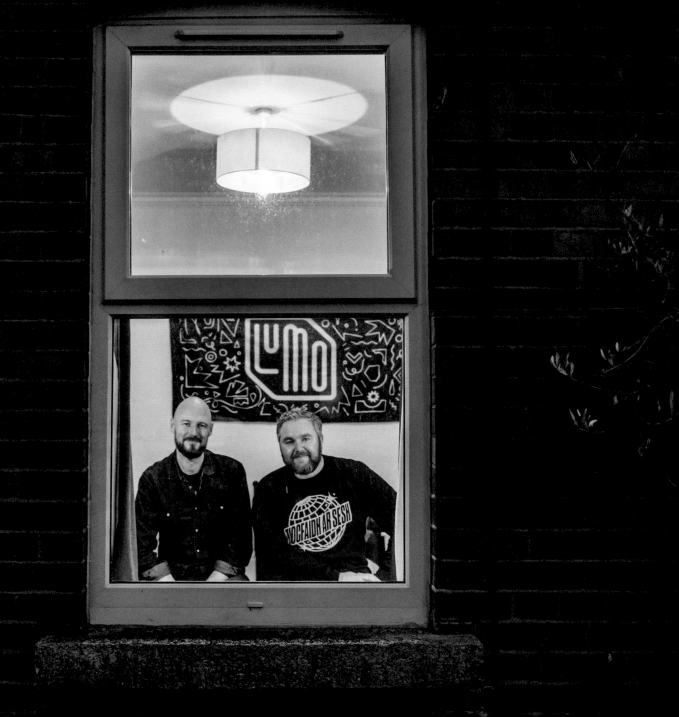

So many of us turned to online community entertainment during lockdown. Yes, I'm talking about table quizzes. They were usually hosted over Zoom, with the nerdiest or most reliable member of your WhatsApp group having spent the whole week writing completely unanswerable questions.

The Nialler9 Music Quizzes were by far my favourite events of lockdown. The leaderboard scores would change as the rounds progressed, and the banter in the comments section was almost like being in the pub. One week I came in 238th place. You might assume I was sad about this, but it made me very happy to think that there were at least 237 other people, in their homes, doing the exact same thing as me.

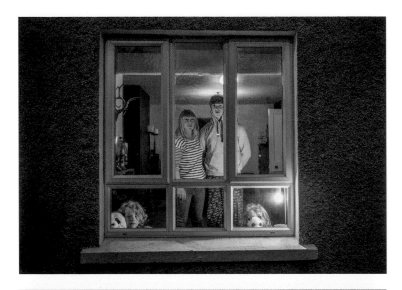

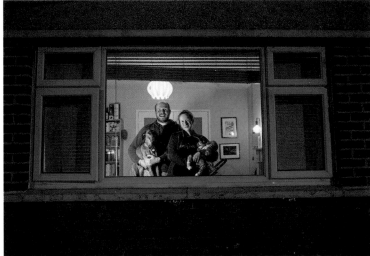

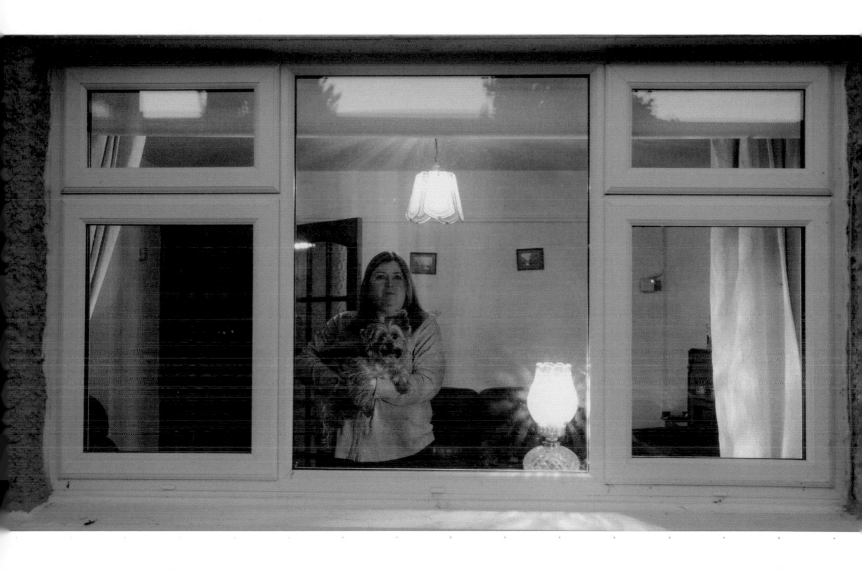

We're a proud nation of poets, and there's none more contemporary and talented than my dear friend Stephen James Smith. He wrote this beautiful piece during lockdown and, like all great poems should, it stopped me in my tracks the first time I heard it.

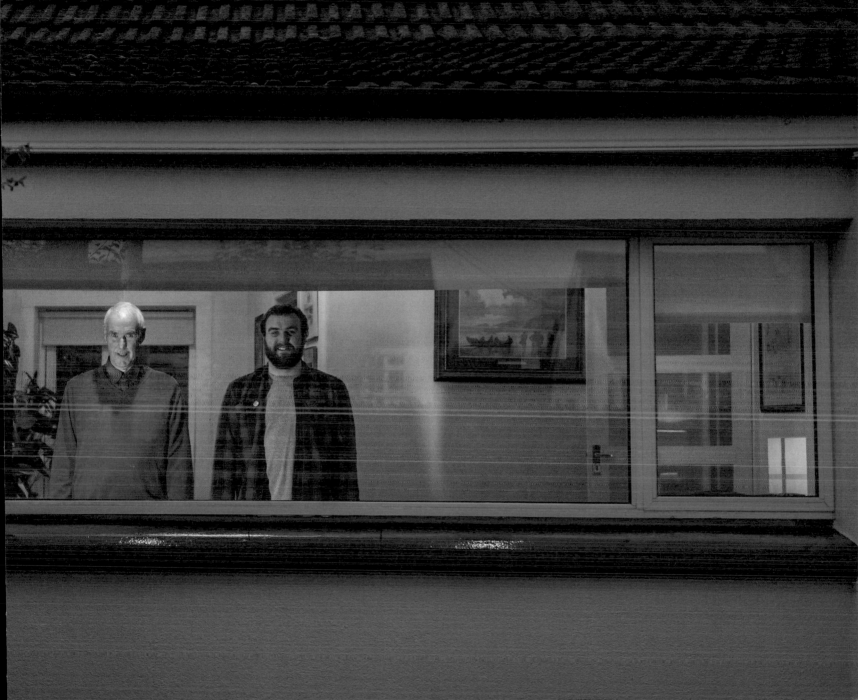

COLLECTIVELY COUNTING

by Stephen James Smith

Counting numbers is a functional kind of meditation, a distraction
in this state of isolation. Let's make a decision to count to ten
together and find a way to weather this hibernation.

1.

How many days has it been? Have you found a new routine?
Have you lost opportunities? New possibilities? New faith in our
authorities or still the same old anxieties? How heartened are you
by the charity found in our communities?

2.

How many are trying to catch our collective breath? Bereft of
touch, on Houseparty drinking too much! How many are drinking
alone? Would feel safer alone? How many are on the latest death
toll? How many comparative charts do we need to console us?

3.

How many expect an impending baby boom? Something to look
forward to amongst the gloom. How many Zoom downloads? Jobs
furloughed? How many had to look up the meaning of that word?

4.

How many businesses with their backs against the wall? Yet how
many received that welcome unexpected phone call? A break in
the rent, a preorder, we're in this together, we're accountable? How
many are re-evaluating what's reasonable?

5.

How many have discovered creativity? Learned the value of art
and opened up to their own sensitivity. Baked bread to find some
normality. Yet how many are still privately privileged in this captivity?
How much increased capacity on Daft.ie due to the decline of
Airbnb? How many epiphanies?

6.

How many unflinching journalists will be the catalyst to cut through
the populist rhetoric? How many idealists, realists wrap themselves
in the flag, at a time of distress? How many care workers, or those
in nursing-home care will be redressed?

7.

How many clap for the front line while sharpening knives? How many comply to save lives? How many hospital tiers? *Sláinte* to your health but *slán* to your wealth. How many facing fears? How much politicking is still done with stealth? How many hands washed? Scars are being masked? Sanitizer sought? Which disaster capital bought!

8.

How many attempted suicides? Heavy hearts praying to god. I hear a light heart lives longest, *maireann croí éadrom i bhfad*. How many cherished yet died for this old sod? How many get by with a wink and a nod?

9.

How many aftermaths? New abnormals? Fish in Venetian canals? How much collateral damage is within the rational? How many great mornings and mourning greatly? How many memorials? How many air miles and carbon footprints saved? Which implies rescue. They say this is tough and aren't you?

10.

How many Leaving Certs lost? How much will the college courses cost? How many sporting occasions, festival gatherings and built-up emotions need to be unleashed? How many empty streets, full coffins, open calls, closed business, quick fixes, slow downs, stillness, in this? To what we bore witness.

How much hope, resilience, reconnection, comfort and thanks? How many? How much? How hard to quantify! How many collectively counting numbers that are people's names? Which gives meaning to our lives.

How many found reason to notice the seasonal change and the weeping cherry blossoms blooming? How many were humbled by their beauty? As collectively we wait for their petals to scatter, to fall all across Ireland and gather on our streets and lonely lanes. A sort of slow washing again of our pains, on the living and the dead. How many will find healing when all has been said?

One thing the distance has exposed, our hearts need to be close, not closed.

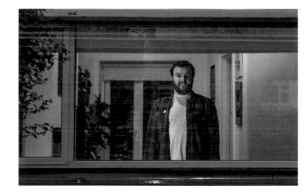

I photographed my friends Fidelma and Martin on their twenty-first wedding anniversary. Fidelma is a doctor, and whenever she was at home with Martin they practised social distancing to reduce the risk of spreading Covid-19 within their home. This meant that I couldn't photograph them in the window together, so they each had a turn.

I doubt that this was the most ideal way to spend their anniversary. I know they'd much rather have been sitting together on the couch, sharing a bottle of wine, rather than at opposite ends of the house. And I'm sure I speak for many of us when I say we're extremely grateful for the sacrifice that all the healthcare workers and their families made during Covid-19. We probably will never know the true extent of everything they did while caring for our loved ones, and while keeping them and us safe.

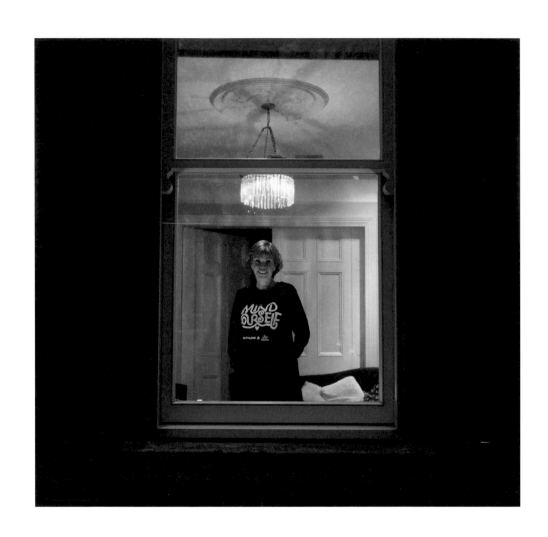

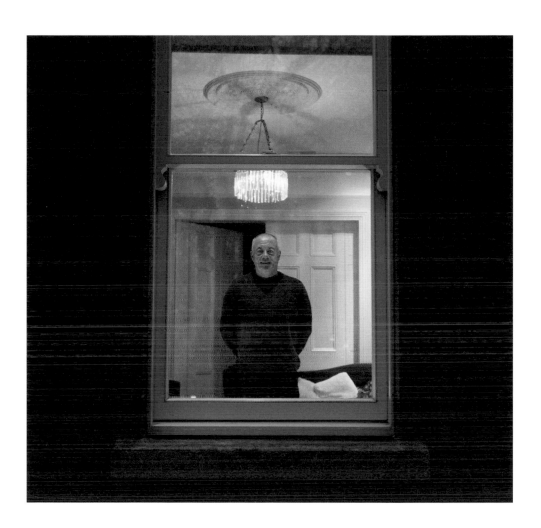

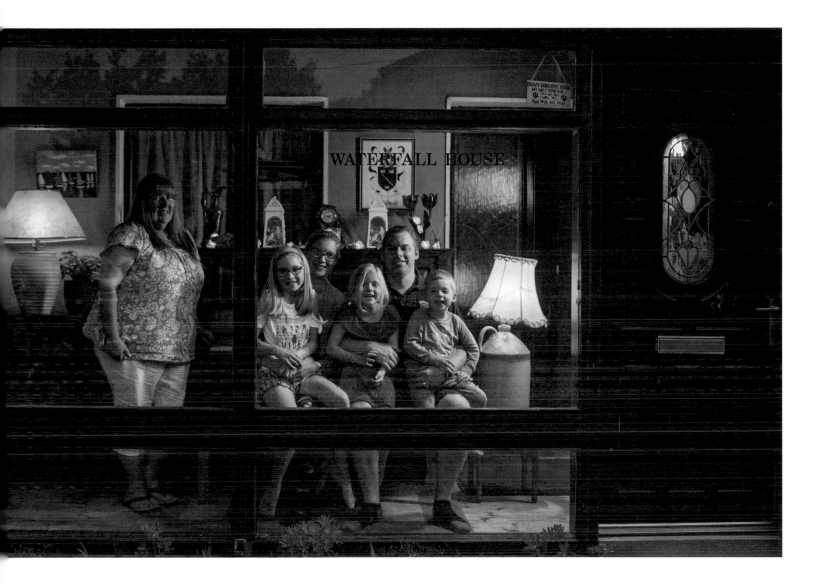

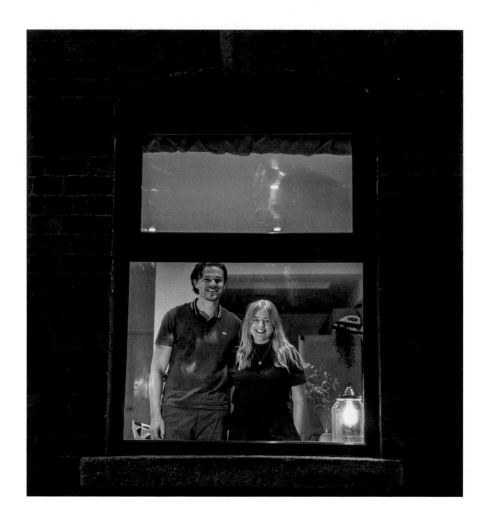

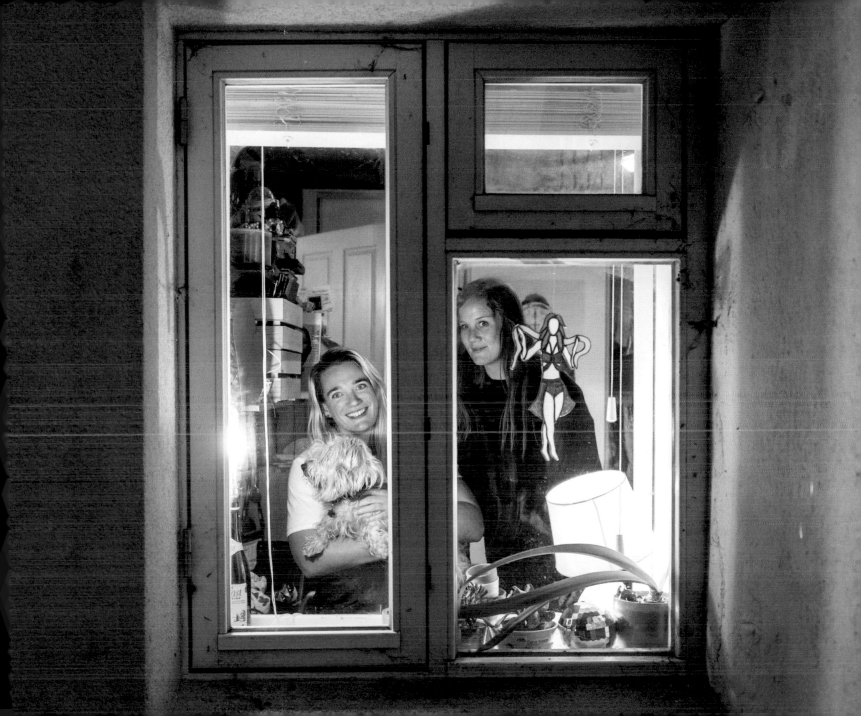

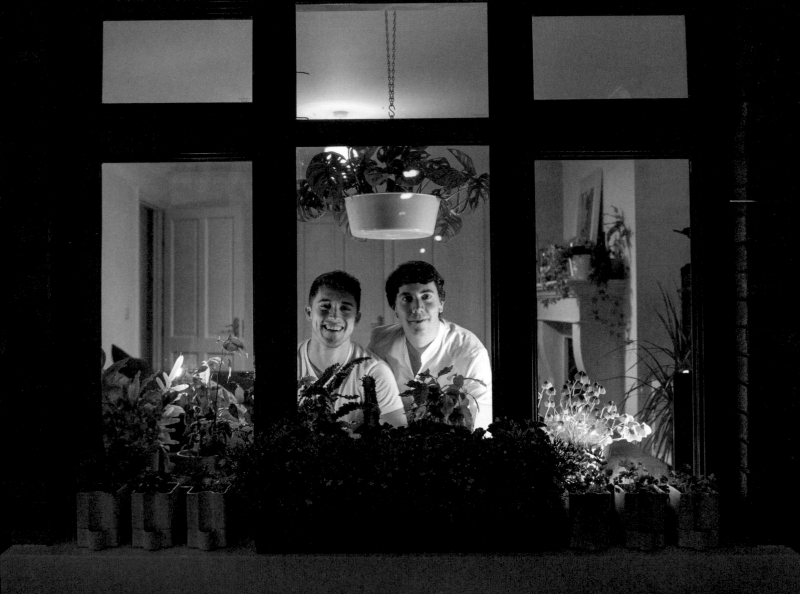

Not only is Joe Caslin an accomplished street artist and activist, but he's also a great art teacher. When I visited Joe and his partner, Jonathon, he was on the front steps of his home in Tullamore, taking in the sunshine while marking assignments from his students. He told me how difficult it had been for the Leaving Cert students in particular, given how this was the first year in its history that the exam was cancelled.

Joe always brings a great sense of perspective to situations. It's as if he's looking down from a great height and is able to see all the elements that are somehow hidden from me.

In the early days of this project, I'd call Joe as I walked home from my twilight shoots, and we'd chat about the pandemic and how it was affecting us both as artists. Speaking to him was like a counselling session. He'd calm me down if I was upset about losing work or frightened about my future, and he'd also pump me up if I needed a confidence boost, always telling me to aim higher.

One night I explained to him my frustration with people who couldn't quite grasp how dire this situation was for us. In true Joe style, he hit me with the following words from a poem by Damien Barr: 'We are not all in the same boat. We are all in the same storm.' The next generation of young artists is safe in his hands.

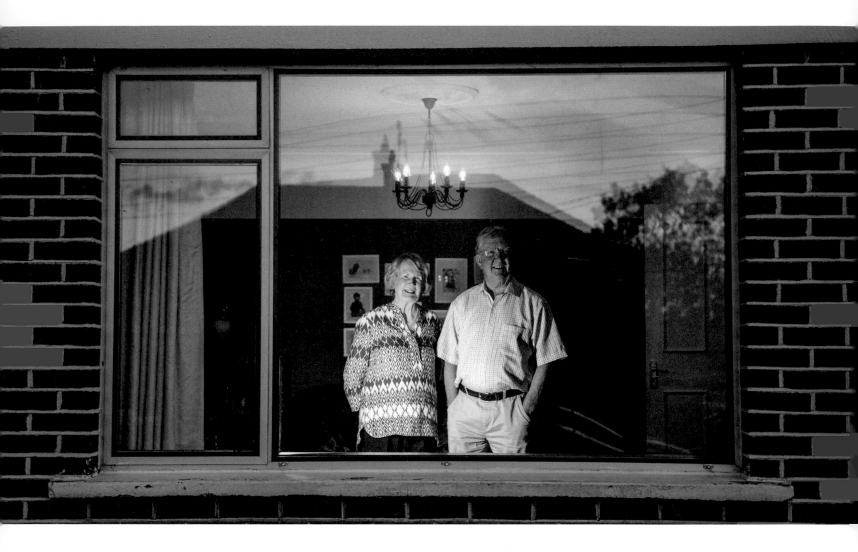

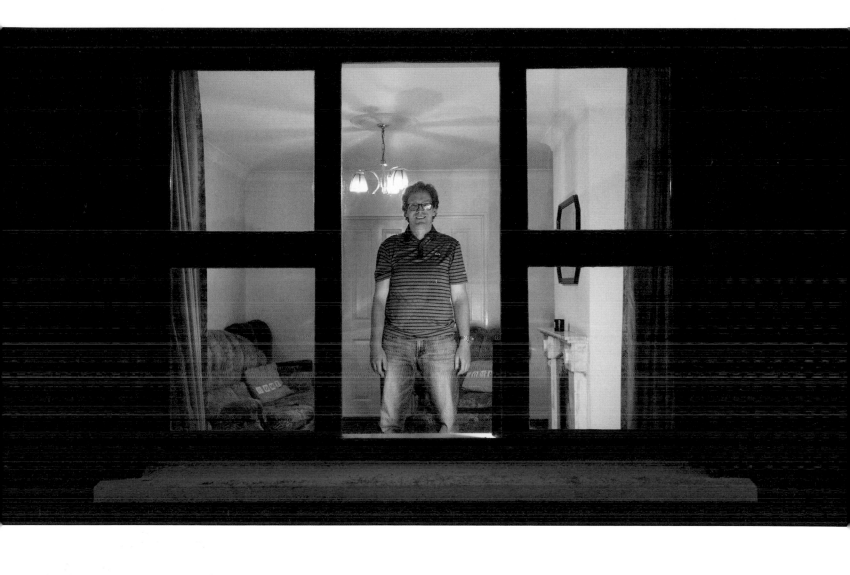

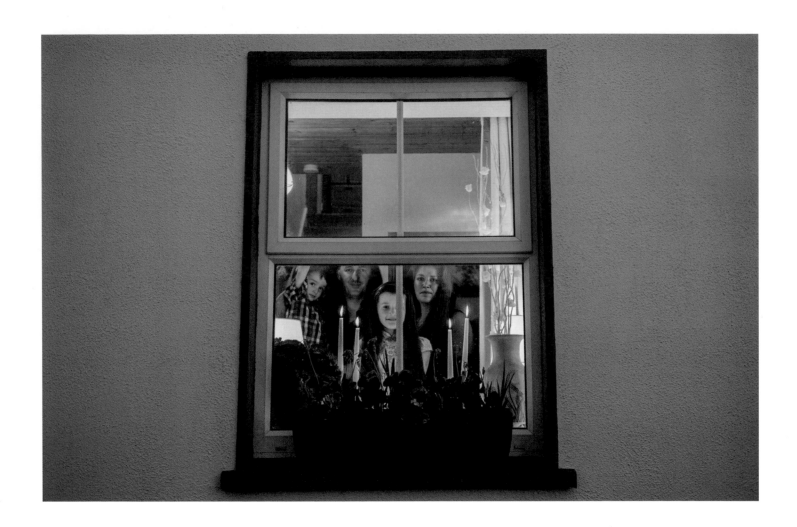

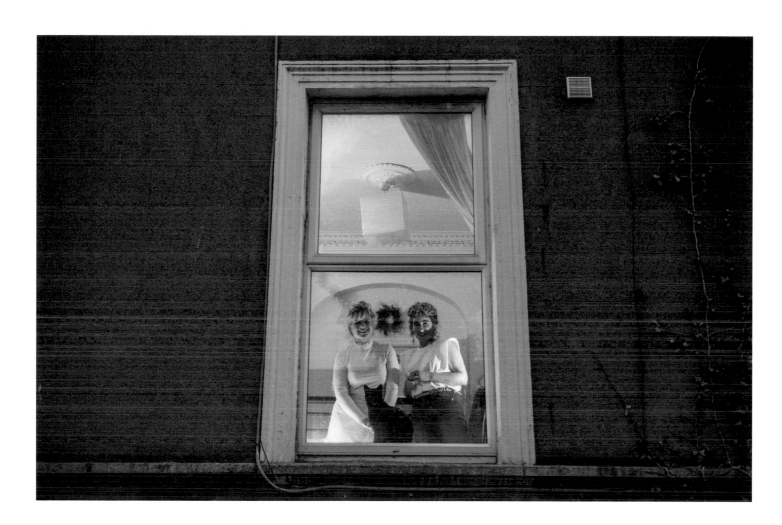

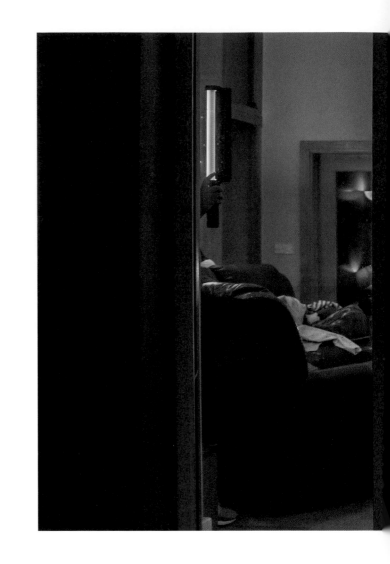

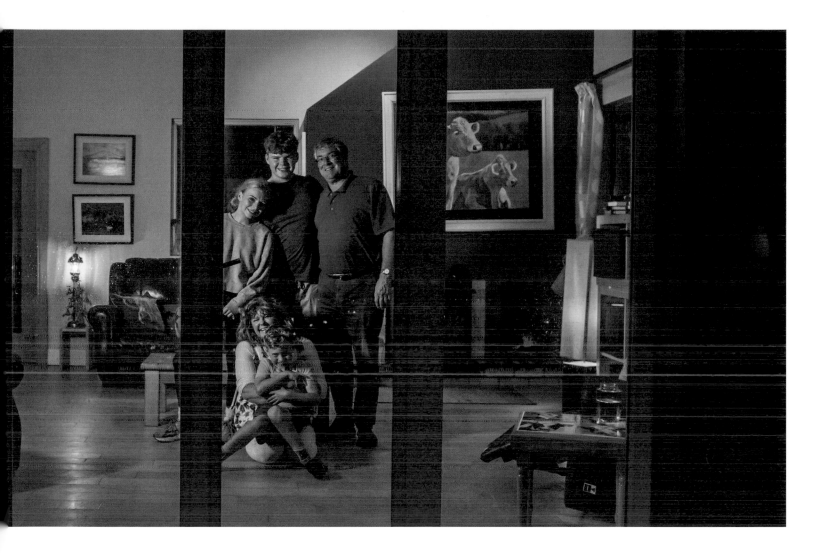

Being from a minority background, I always make sure that my work is as inclusive as possible. I want it to be a true representation of all the people and communities of Ireland. I want people to have the opportunity to recognize themselves in the portraits – their own ethnicities, religions, races and cultural backgrounds. This was something that was missing from my life when I was growing up, and I'm trying to change things for future artists.

One of the highlights of my travels was a trip to Cork to meet Leanne and her family. She is a young, successful, female photographer from the Travelling community and I'm always excited to meet more women in my line of work. I met her and her family outside their lovely mobile home. Her charming young boys were excited to have a visitor, and begged me to watch them do tricks with their football (they hadn't had an outside audience in months).

I was amazed by this woman, so much younger than me, with a bright career, a beautiful family and an incredibly strong sense of self-worth. I'm honoured that my small circle of friends has grown to include her, and I'm so happy that young members of Leanne's community will grow up with her as a role model.

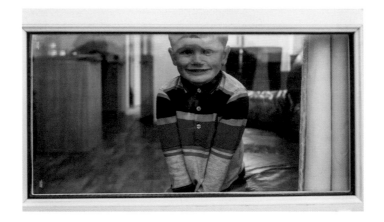

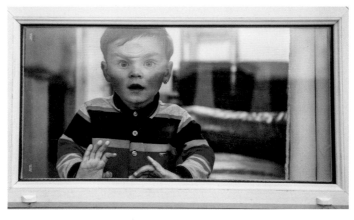

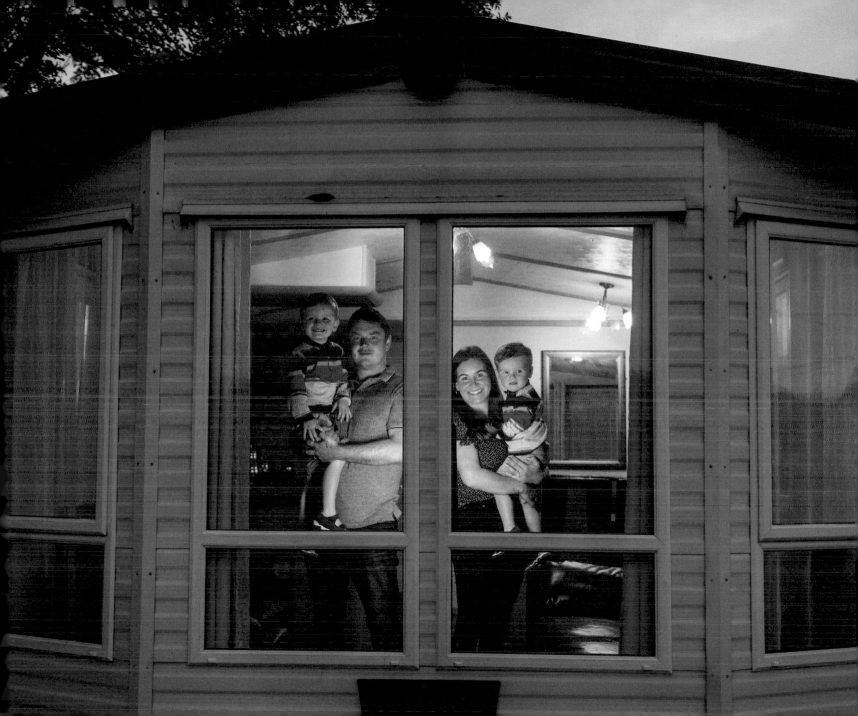

What if you've been building your career patiently and delicately over the course of many years? If you've been carefully assembling the building blocks to get you to where you dream of being? Then, just as you're about to take off, everything comes to an abrupt halt? The rug is pulled from under you, the control you have over your own future taken away?

In 2019 I toured Europe with David Keenan. I photographed him every day as he played gigs in new towns and cities. During our down time we would create art – me recording him as he recited poetry on Polish rooftops. He was touring as the support act, but by January 2020 he had sold out the Olympia Theatre and was set to make his name in the music industry. It was going to be his year.

When the pandemic struck, it placed so many young artists' lives on hold. David is resilient, though. He's found new ways to create and (with the help of his incredibly supportive family) he'll survive this. He'll reignite the momentum, he'll reschedule his tours, and he'll make his way back to centre stage once again. Twenty twenty-one will be his year instead.

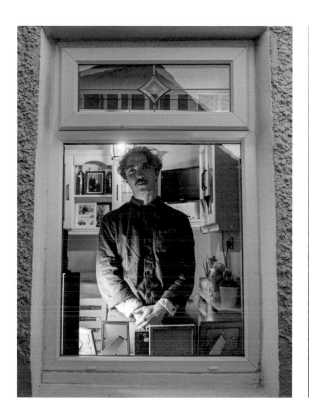
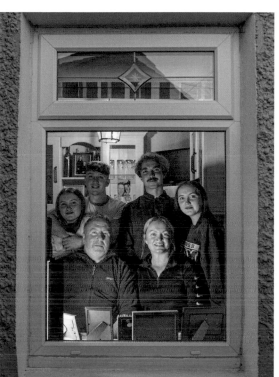

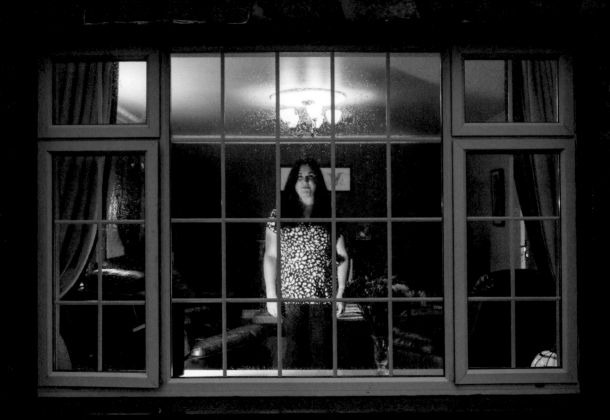

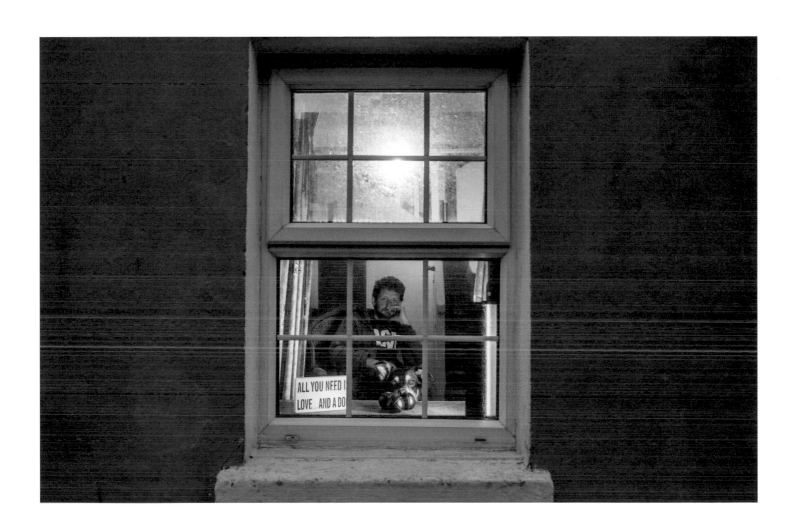

Only once we were all confined to our homes did we realize just how important the Arts were to our everyday lives. The books we read during lockdown, the films and TV series we watched, the poems quoted on the news after a particularly sombre broadcast. The musicians who sang to us to ease the pain of losing those we loved. The sense of togetherness we felt while we all watched a TV show at the same time, or listened to albums together over social media. We looked to artists for creative inspiration, for hope, for entertainment, for laughter. I hope this recognition of the worth and value of the creative industries, as well as our new-found gratitude for them, is something we can collectively carry forward.

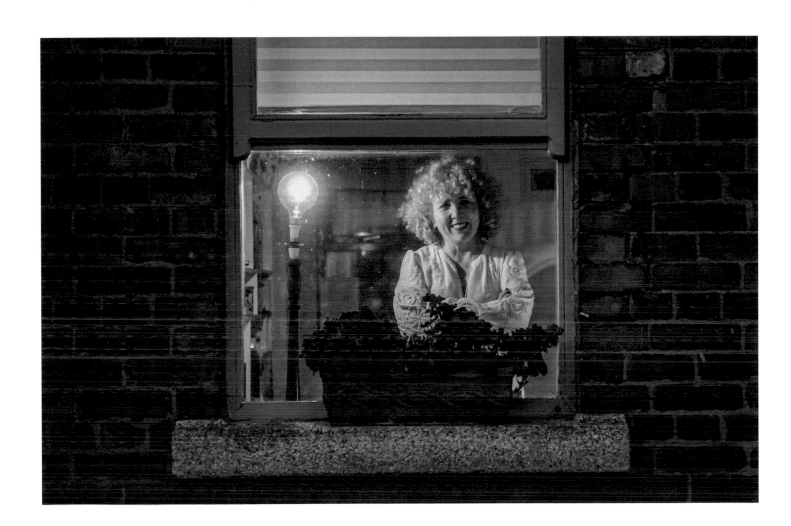

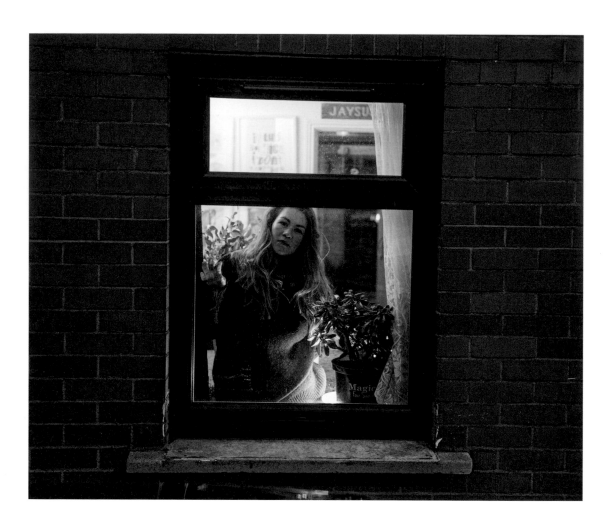

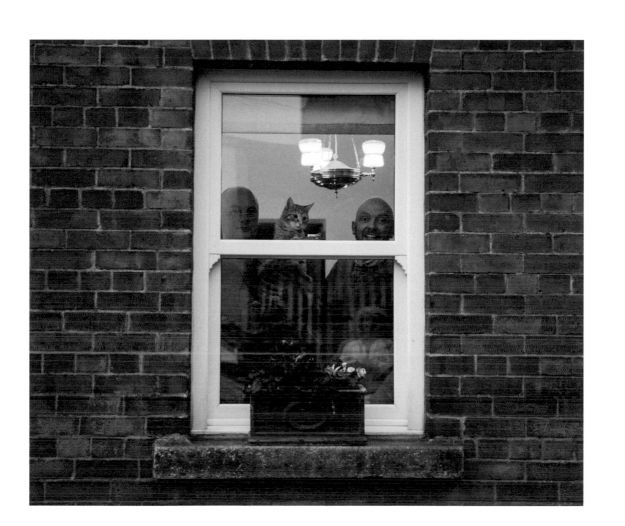

Being single in the age of online dating was already hard enough. Dating during the lockdown was totally impossible. Not only did you have to connect with someone within your 2 km (or, later, your 5 km) radius, but when you did meet, you also had to stay at least two metres apart. On top of that, no bars or restaurants were open for a tipple of Dutch courage.

Sunday afternoons in the park became the new hotspot where, if you sat for long enough, you'd see some awkward first dates play out before you. Those in relationships were considered lucky – at least they had someone with whom to pass the long days. Someone with whom to share a bottle of wine, a meal, a dance in the kitchen.

Though I know spending that much time together can't always have been easy, the couples I met on my travels were far from annoyed with one another. They were the epitome of #relationshipgoals. They embraced, kissed, bounced off each other, and played out funny 'bits' for the camera. Their love poured from their windows and gave all the single people passing by on their awkward dates a glimmer of hope.

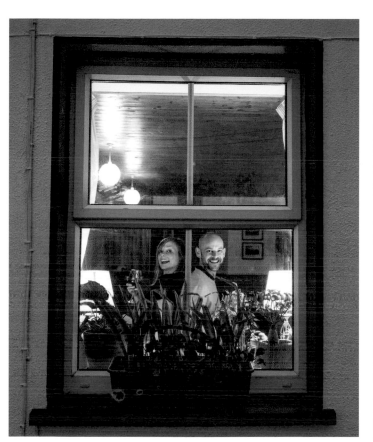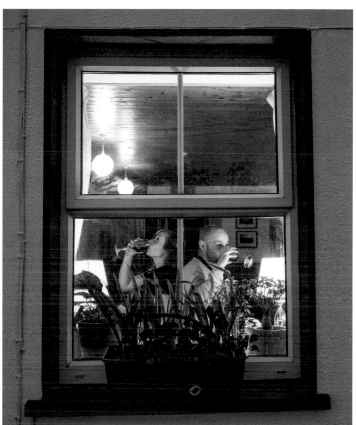

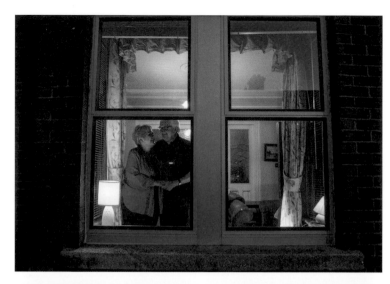
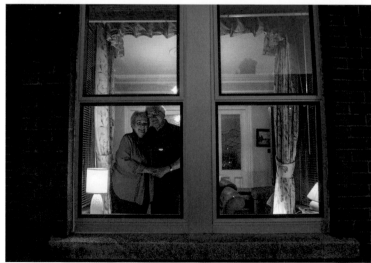

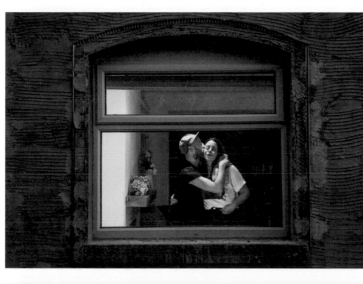
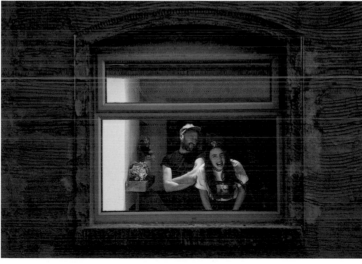

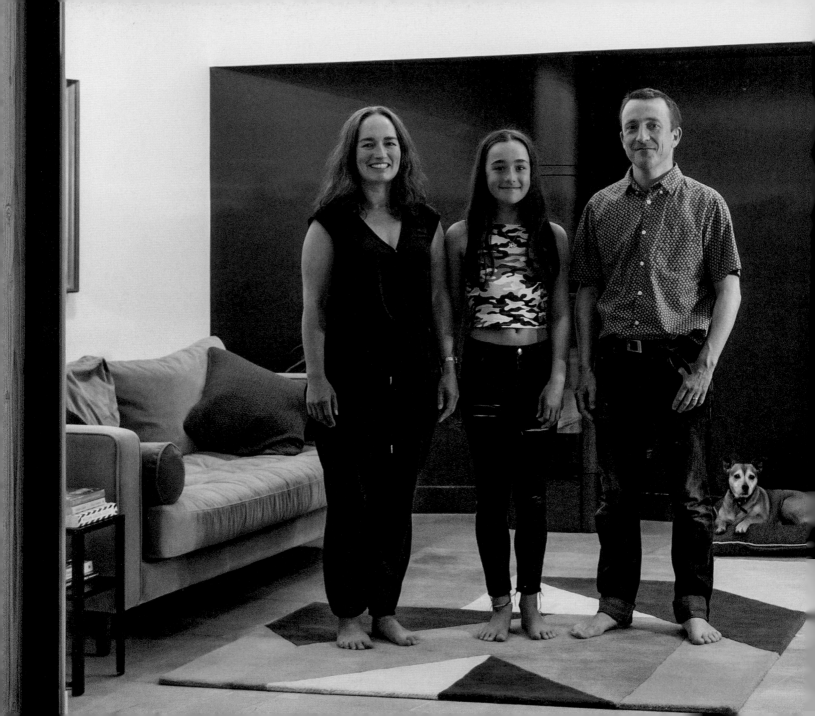

During lockdown, Zaï the Connemara pony, who usually lives in stables, was brought back home to live closer to his owners, Lucy and Delo.

'This is probably the first time he's ever seen me inside the house,' said Lucy through the window as Zaï tried to figure out what on earth was going on.

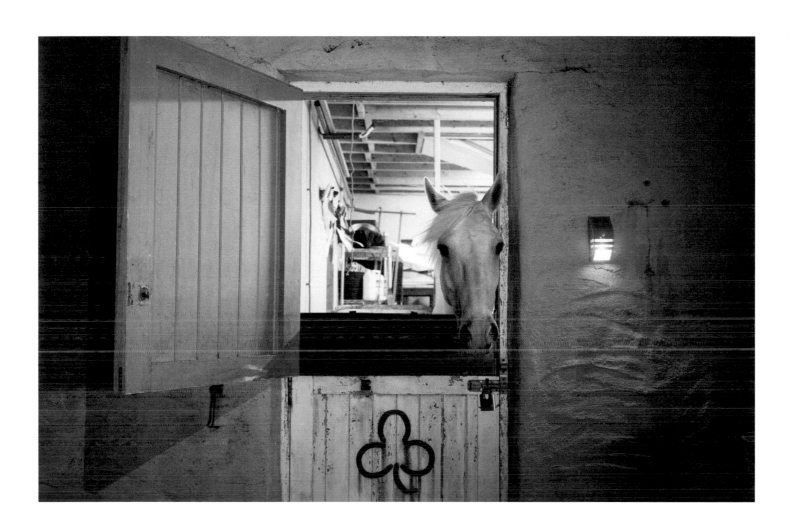

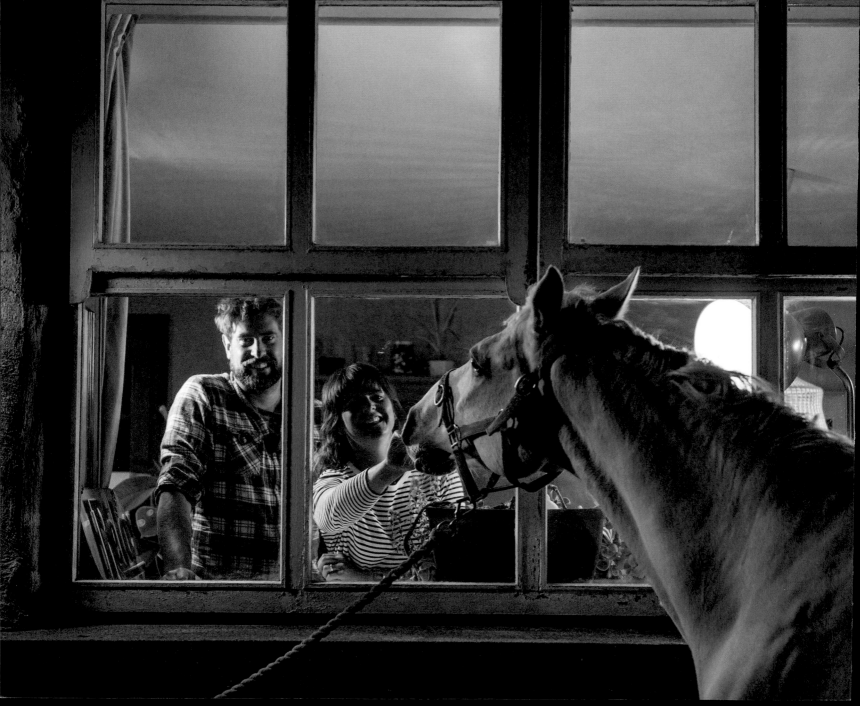

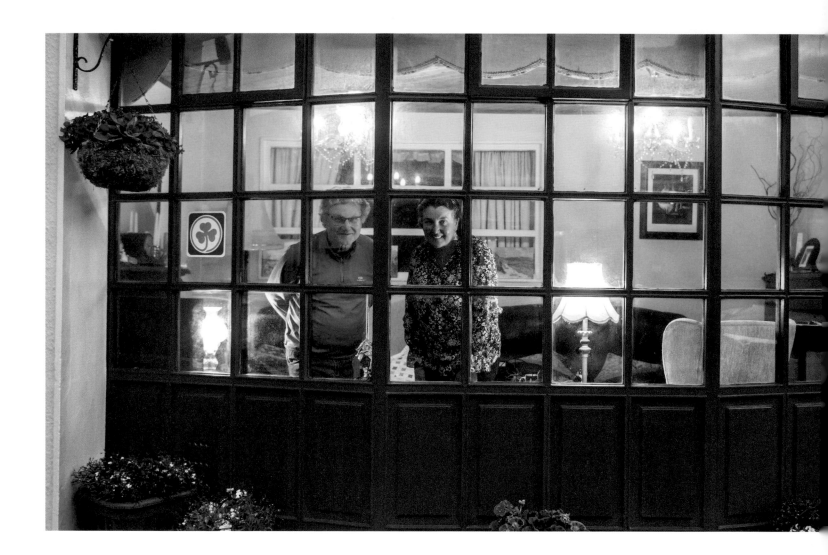

When I photographed the beautiful Connemara town of Clifden, it was the warmest day of the year, yet there was hardly a soul in sight. The streets smelled like fresh paint as business owners painted their windowsills and door frames, brightening up the place in the hope of reopening soon.

Regina told me that her dad constructed the windows of her B & B, which look straight on to the street. Everybody waves at her and her husband, Jim, as they pass by. Usually, her B & B is full of hustle and bustle during the height of summer, but the arrival of Covid-19 caused an unexpected and sadly ubiquitous lull in business for small tourist towns across Ireland.

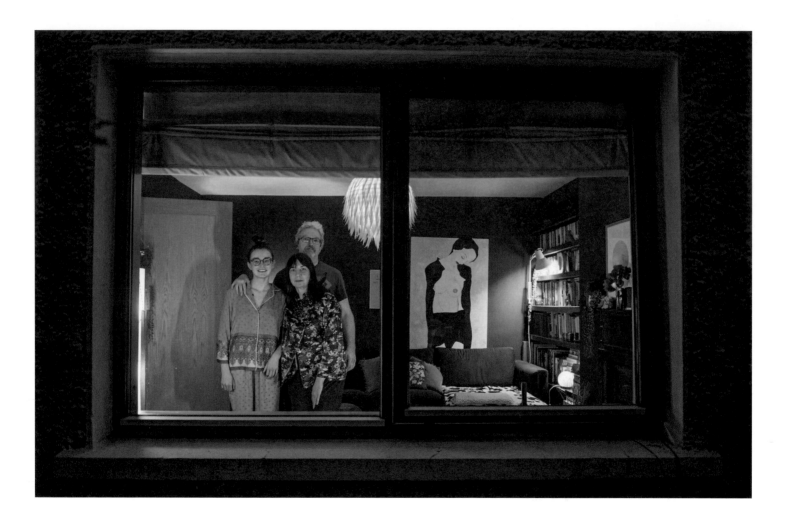

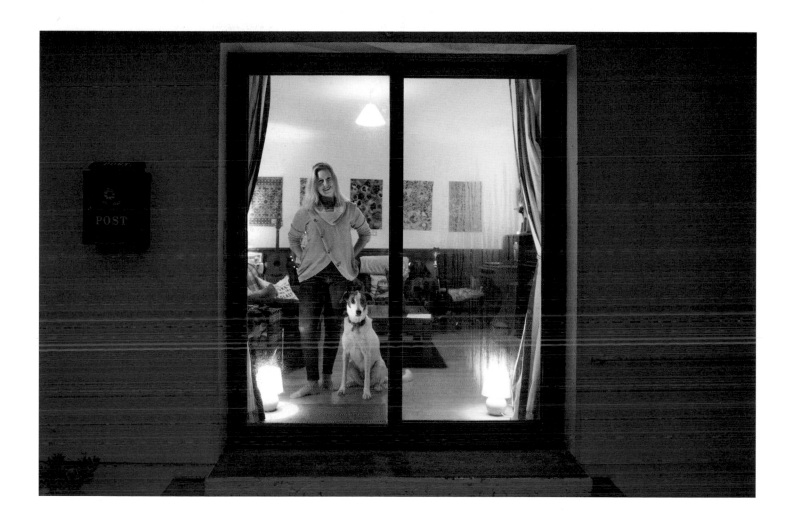

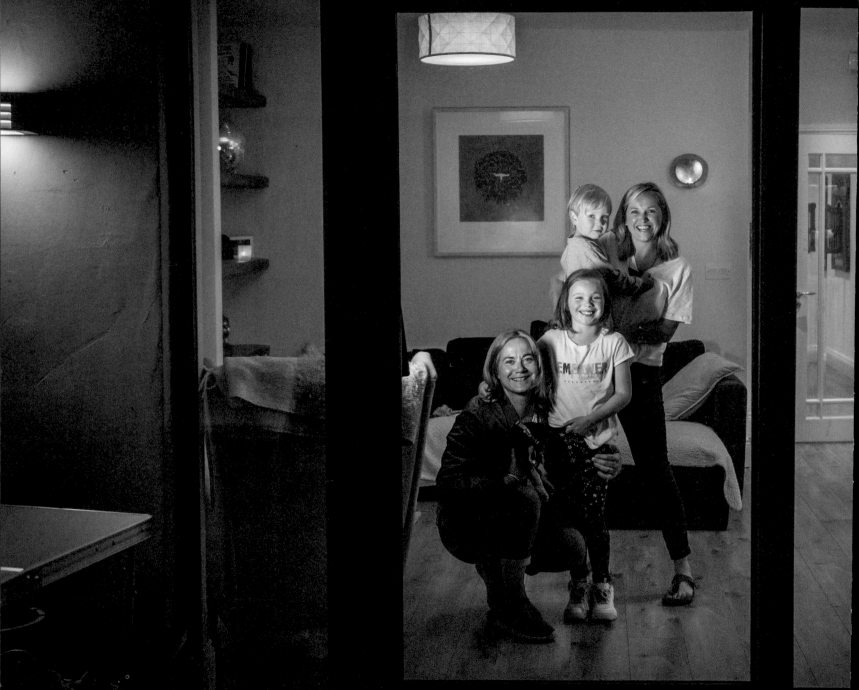

Supermarket staff, warehouse workers, couriers and delivery drivers. Along with healthcare workers, these were some of the people we'd come to know as our new heroes. They were thrust into a new world of responsibility and great risk, and sometimes not given any choice in the matter.

While we were at home listening to the nightly numbers of new cases, these folk were out working overtime. They kept food on the shelves and made sure essential packages were delivered to our doors. They dealt with each new measure and restriction thrown at them, usually without the benefit of a bonus or a raise. They've shown us truly how important their jobs are, and that strength in a community comes from everybody, working together.

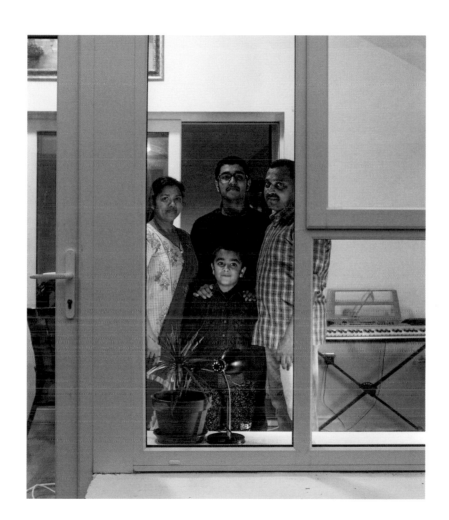

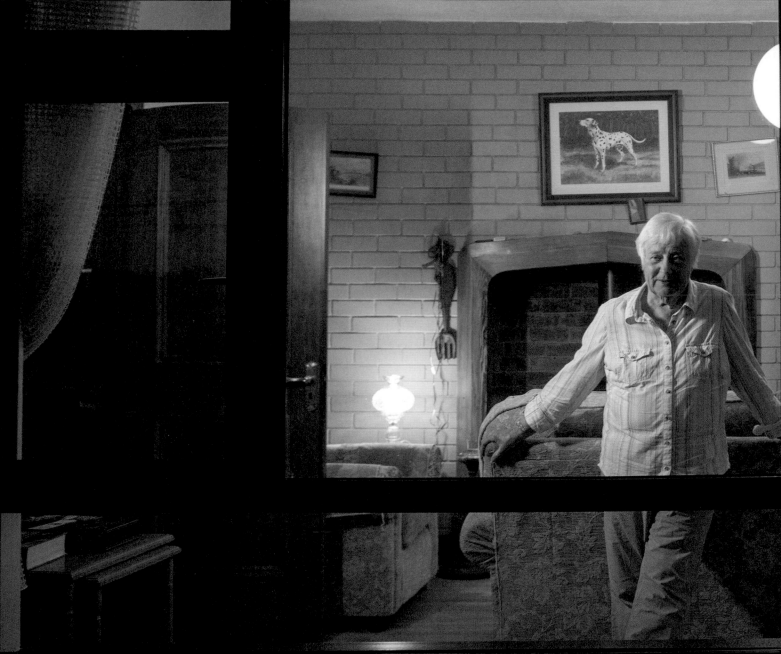

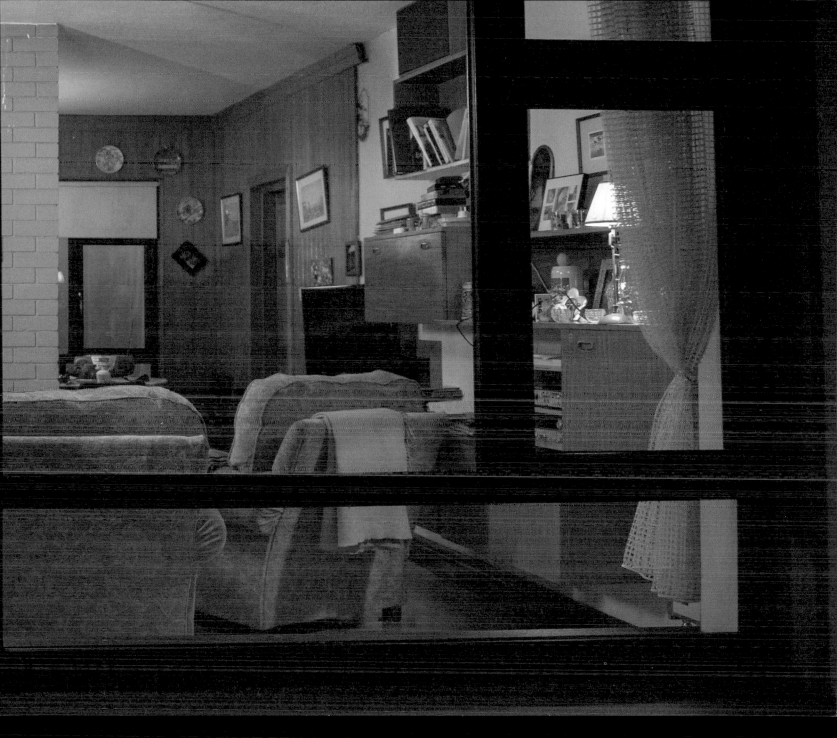

The rain was coming in sideways that night. I was soaked through and exhausted by the time I reached Star Cottage, the home of Mary, her daughter Katie, and Katie's young family. I may not have been allowed to go inside, but that wasn't going to stop them from offering me a drink. Before my arrival a choice of cans of beer or a bottle of wine had been carefully tucked under a bush below the window. They had even included a corkscrew.

The rain cleared up almost as soon as I clicked the last photo and, once the kids were handed over to their dad, Mary, Katie and I stood outside. Two metres apart, we drank and chatted under the summer solstice moonlight, and looked out over Ardmore Bay.

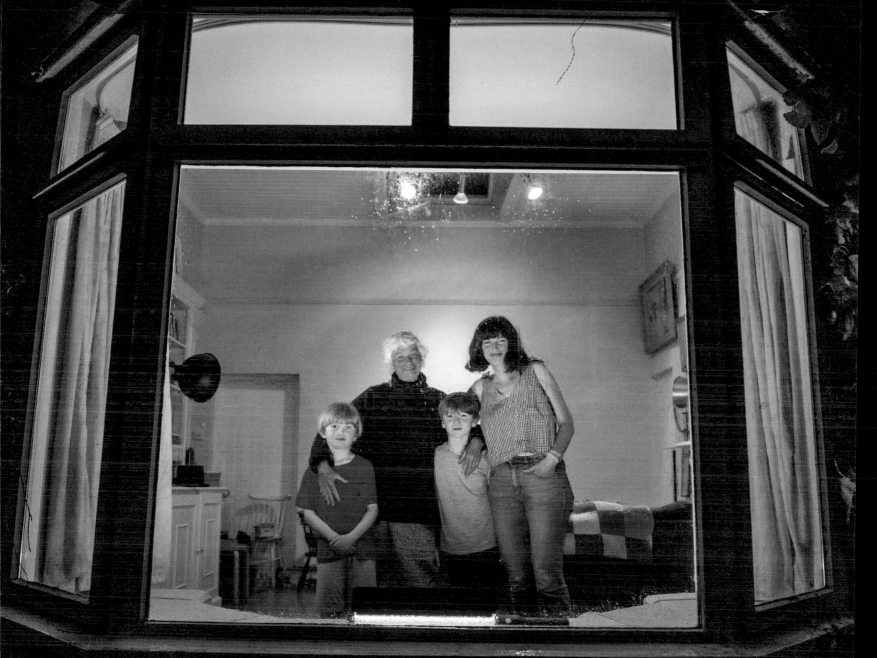

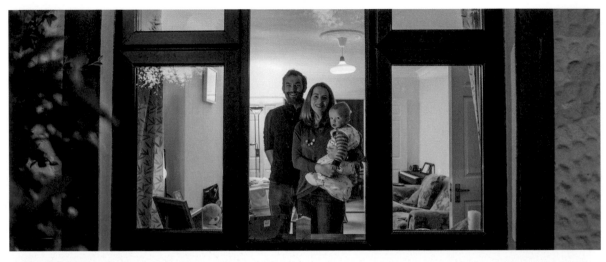
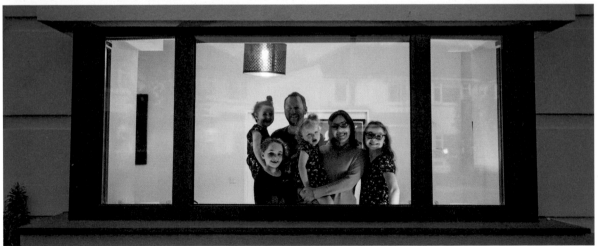

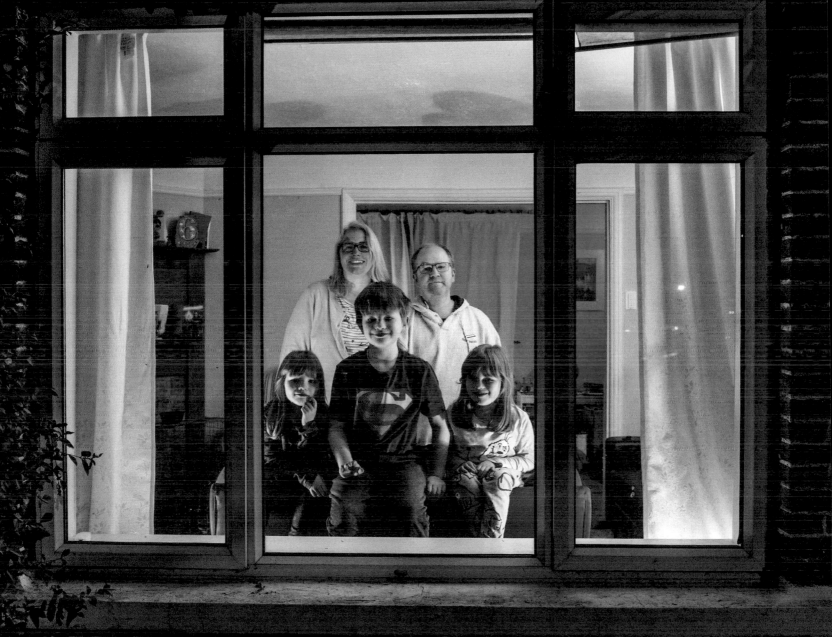

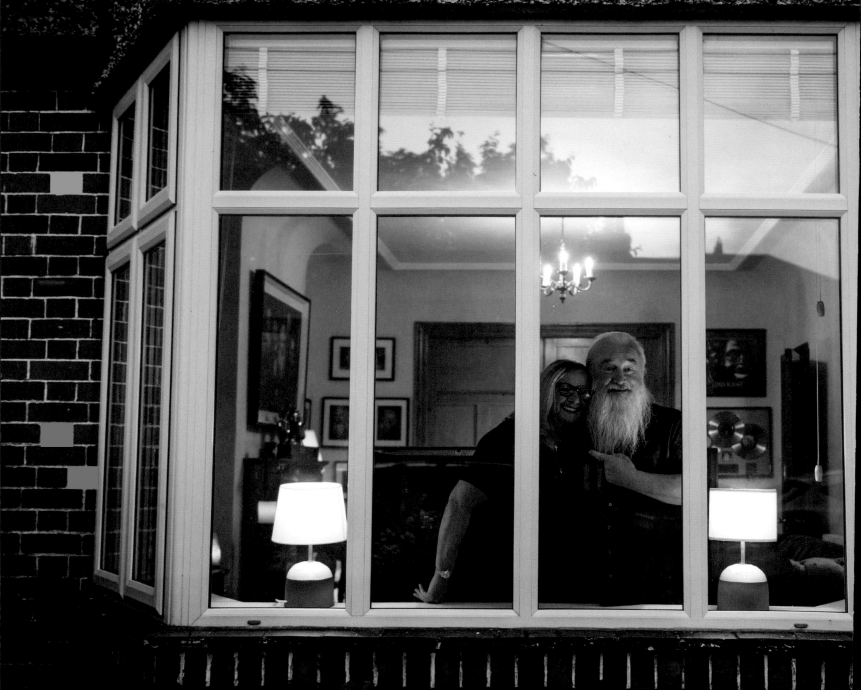

One of the most unexpected revelations of this project was just how lovely people can be. Every night of my travels I met a lot of new friends – people with whom I had communicated only by text or email.

The invitation to be a part of the project was an open one. I made my email address known on my social media channels, and all anyone had to do was reach out and tell me where they lived. A huge number of people got in touch (in one night alone I received over 400 emails), and when the stars (and Google Maps) aligned I was more than happy to take their portraits.

What I wasn't prepared for was the kindness I was shown by these lovely strangers. I was offered a lifetime supply of tea. Sadly, I could never accept a cup, as not only was I short on time, but there was also social distancing to consider. On many occasions, gifts were strategically hidden somewhere in the garden. Some even had little bottles of hand sanitizer left beside them so that I'd know they were clean.

There were bottles of wine, colourful cards drawn by the children, beauty sets, candles – all things you could pick up from the local supermarket or chemist, as every other shop was closed. The thought of these total strangers going out of their way melted my heart each and every time. Overcome with emotion, I was often close to tears when I said my goodbyes, wishing I could join them for that cup of tea.

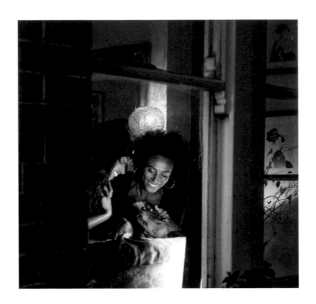

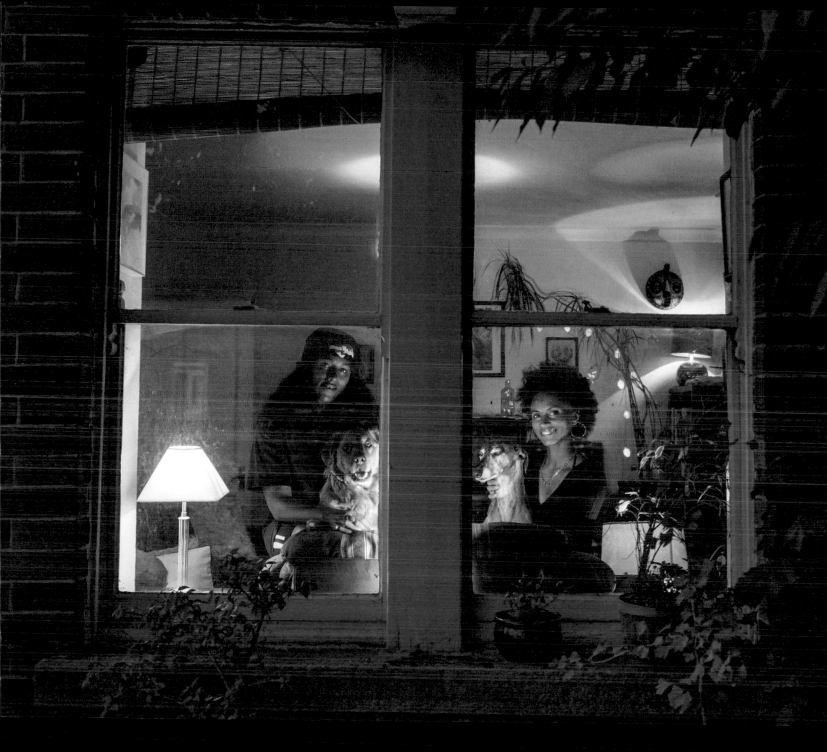

Some events in 2020 were bigger than the pandemic – they spurred reactions and mobilized millions of people across the world. In Ireland, the Black Lives Matter marches, protests and vigils proved just how much many Irish people cared about the atrocities happening in the US, and how vehement we are that racism is not something that is welcome here. Musician Erica Cody spoke out and was a strong voice that many people needed to hear, articulating an uncomfortable but necessary truth with passion and dignity.

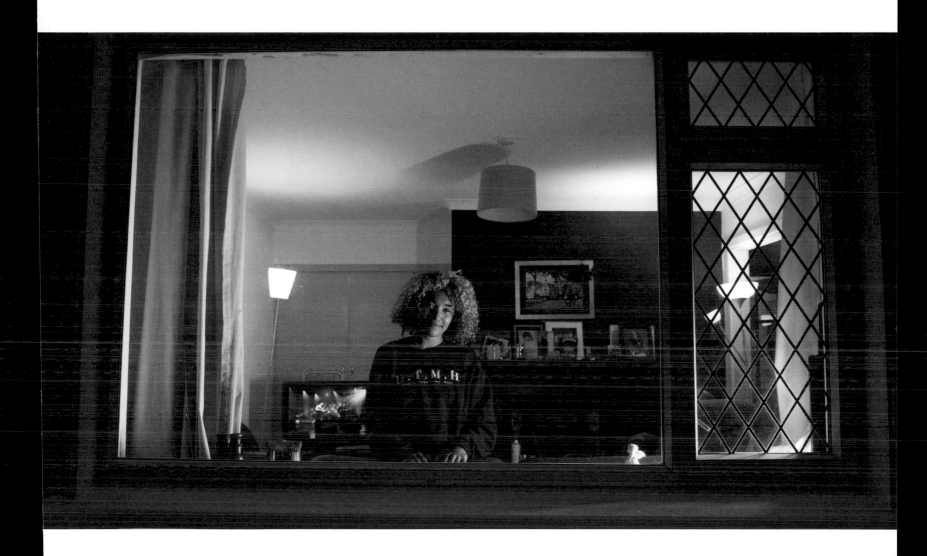

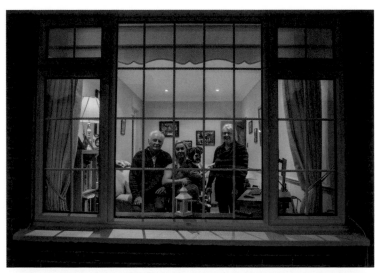

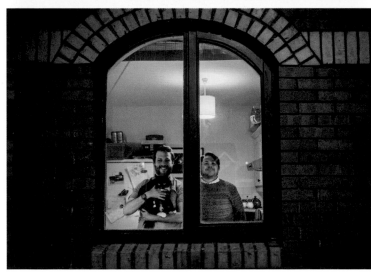

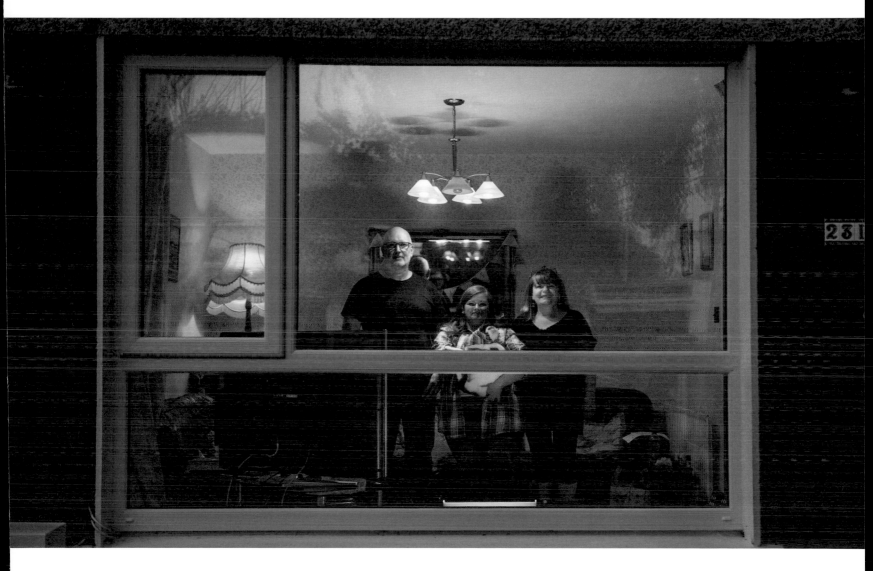

If I had a few homes to shoot in an evening, I would map out the most efficient route between them. Whenever I could, I'd make sure to put my friends at the end of the itinerary, so that I could stay and chat for longer, in an attempt to quell my own lockdown loneliness.

When I photographed Simone and her partner, Mark, theirs was the last house on my round that night. I hadn't met Mark before, but every time I had chatted to Simone in the past, I had always wanted more time. She's one of those loving and warm people whose company you can just sink into, and it turns out that Mark is just the same.

Sadly, Simone's mother, Claudette, died during the pandemic. When we lose someone close to us, we tend to gather together and support one another. We celebrate that person's life as a community in order to remember them. We draw support from the love of those around us and we fall into deep, comforting conversations with good people. So many people were deprived of these rituals during lockdown. The restrictions on gatherings meant that funerals were attended by only a handful of people. There was no wake, and no place to congregate and share stories.

There'll be a lot of grieving done, when we all feel like we can breathe again. We'll have so much trauma to unpack and sadness to process. Some more than others.

Simone asked to be photographed wearing her mum's traditional African dress. A tangible comfort that she can hold and cherish, and one that helps her pay tribute to her mother.

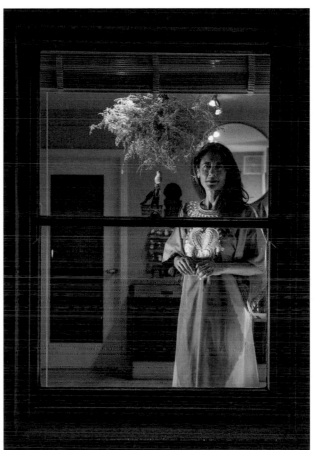

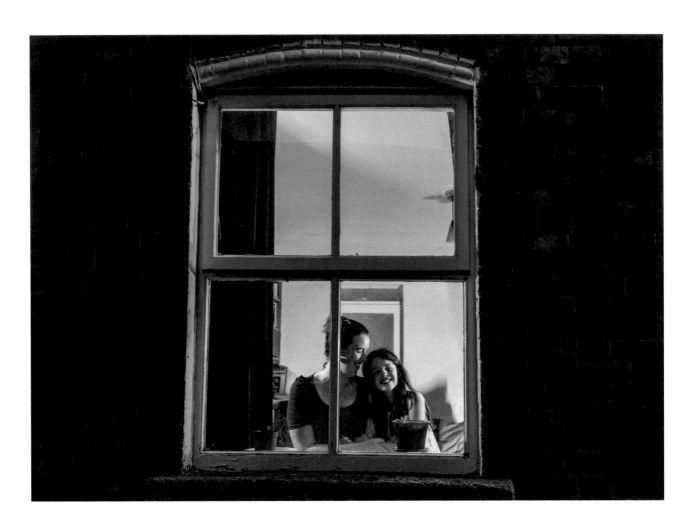

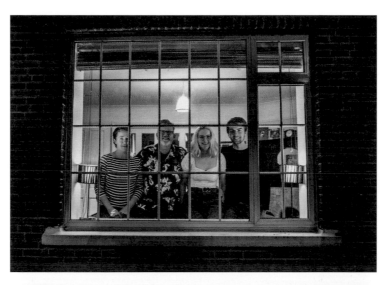

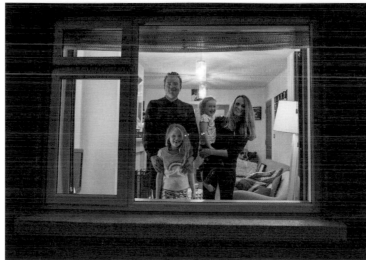

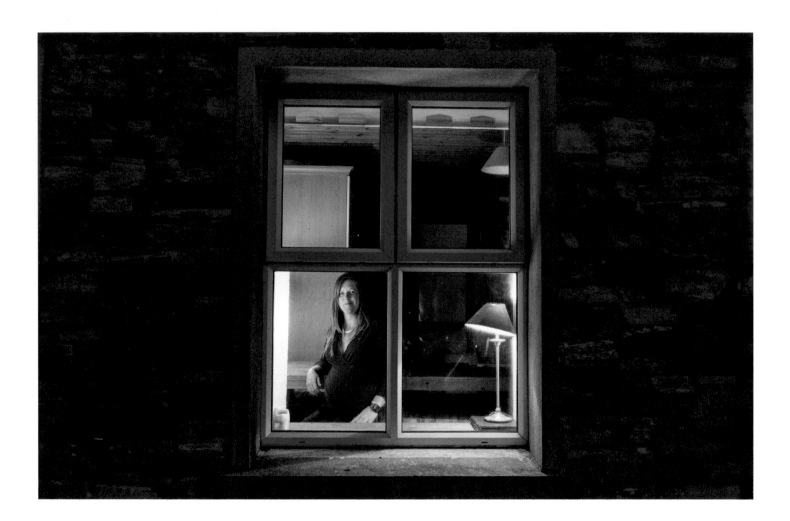

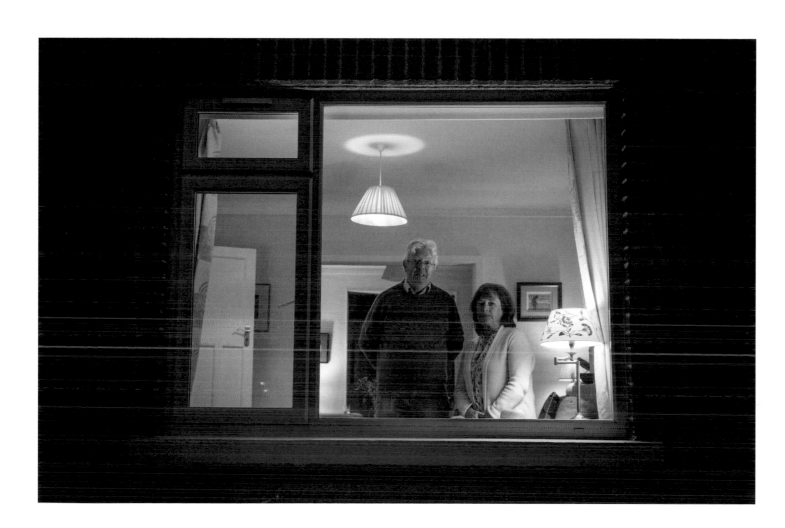

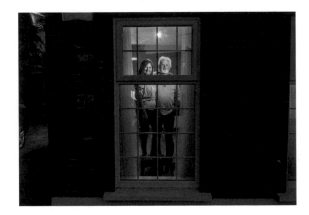

When the news came that, as a nation, we'd soon have to lock down and cocoon, many young city-dwellers headed for 'home home'. They did so partly to look after their parents, and partly so that their parents could look after them. After all, a big house with comfy bedrooms and a lush garden would beat a cramped house-share in the city any day. The one thing we don't have much of in cities is space, so it made sense, especially when people were able to work remotely.

Spending time with your parents when you're old enough to understand what they went through to raise you is a lovely thing to do. For many, lockdown offered a rare opportunity for empty nests to feel full again, even if just for a short while.

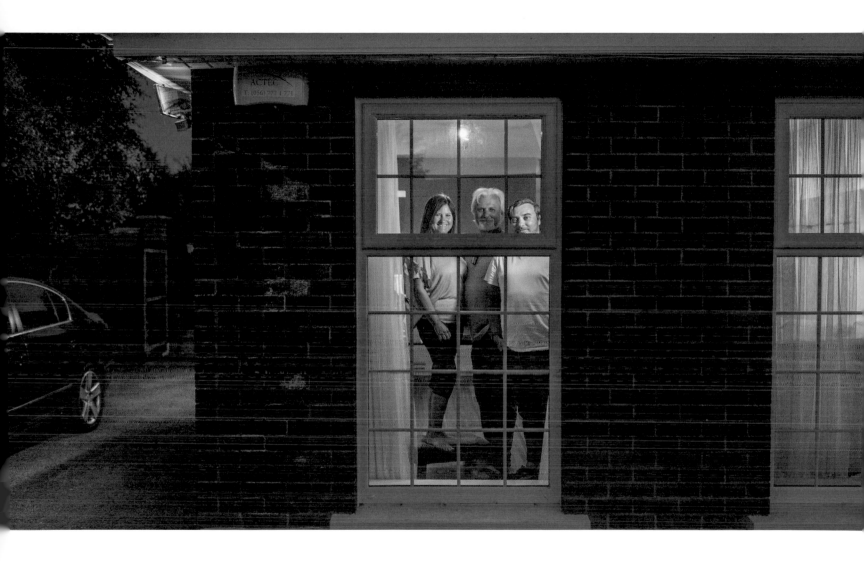

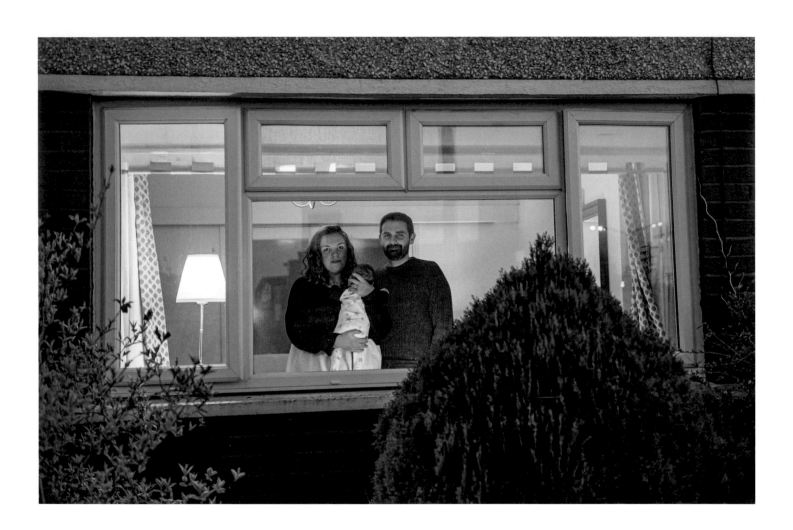

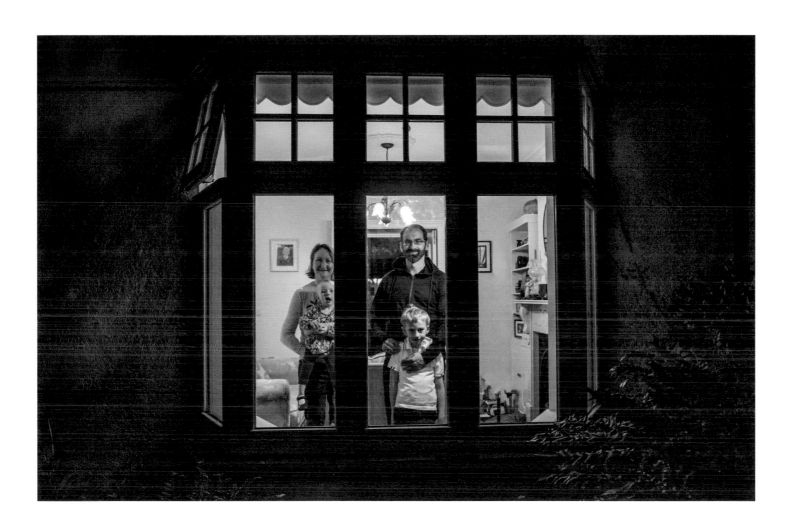

I visited a couple in Wicklow whom I'd come across online. Meeting new people was the highlight of this project, but on my way home from this visit, I stopped the car, stared at the sunset and the beautiful waves lapping on our shores, and was overcome with sadness.

I'm a very proud Irish woman. I'll gladly let my accent sing loud across the world as I travel. I want people to know I'm Irish. We're known for our welcomes here. Our friendliness, our warmth, our sense of community and togetherness. Or are we? There is darkness in Ireland too – something that I'm embarrassed about. Part of this darkness involves our Direct Provision centres and how we 'welcome' asylum seekers.

Ben and Bernie have been together for years, and their love is beautifully obvious for all to see. Their home is filled with plastic bags, which Bernie distributes to Direct Provision centres. She wears herself out collecting and delivering donations. She brings food to people who are undernourished, and clothes to kids who are outgrowing what they have.

At the beginning of lockdown Ben was given a devastating deportation order. While we were all settling into our homes, Ben was contemplating losing his. He has lived in Ireland for fourteen years. During this time he has studied hard and bettered himself. He has made friends and become part of the community. He is a warm, gentle, intelligent man, who speaks passionately and courageously.

I think what upset me most was that he reminded me of my dad, someone who also came to this wonderful country many years ago. I couldn't bear to think what would happen if the rules were to change and my dad was sent 'home'. All Ben wants to do is live here, work hard and be a partner to Bernie in all the ways he can. Someone, somewhere, decided against it. They rescinded his welcome, his *céad míle fáilte*.

By the time this book is published, Ben will know if his campaign to stay in Ireland has been successful. I hope he's reading this at home with Bernie, a view of the Irish sea before him.

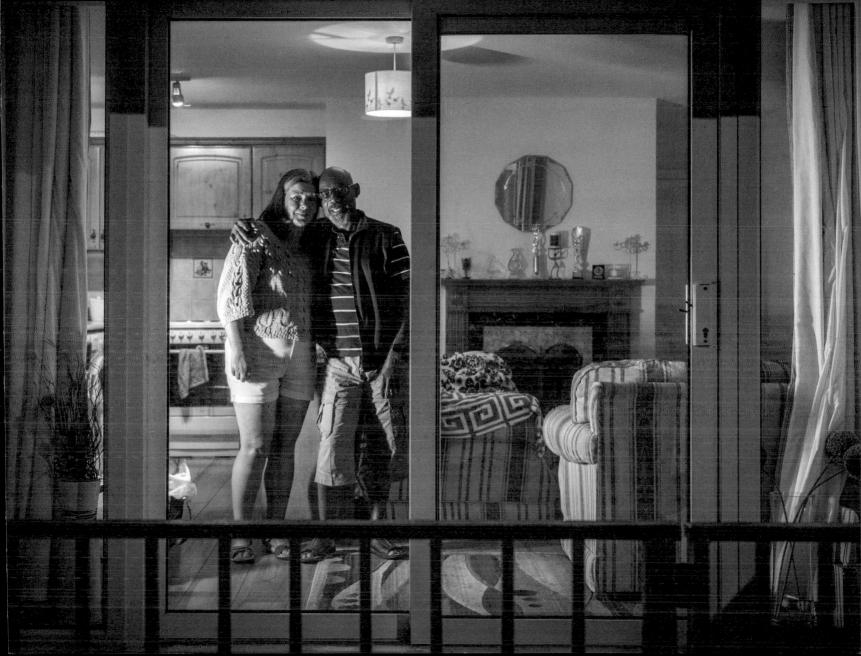

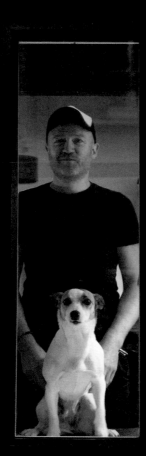

The ones who truly benefited from lockdown were the pets. Our dogs, cats, bunnies – they all loved us being home so much. When photographing a household that included a furry friend, we had to time it perfectly so that the dog wouldn't lose interest or the cat wouldn't squirm away.

Most homes would email in advance to warn, 'We have two adults, two children and a cat, but don't count on the cat being in the shot!' I learned very quickly that cats just do whatever the hell they want.

My pockets contained both dog and cat treats, which I'd pass through the open window to the pet in question. I'd make *psp-psp-psp* noises or pretend to have a ball to throw – I even bought a laser pointer for the cats. Neighbours across Ireland were simultaneously worried for my sanity and their safety as they saw me in next-door's garden, howling in the dark. As much trouble as it is photographing animals, they're always worth the effort. It wouldn't be a family photo without them.

Steven Douglas has designed the stage lighting for some of the biggest bands in the world, including The Killers and Hozier (on whose tour I met him). His light shows are incredible, dazzling visions of strobe lights and lasers.

On the night I went to photograph Steven and his gorgeous family at home, it was a dark and rainy evening. There wasn't a glimmer of moonlight or sunlight to be seen. Just as I went to take the first few shots, a fantastic flash of lightning flared across the sky. I swear that Steven was somehow behind it.

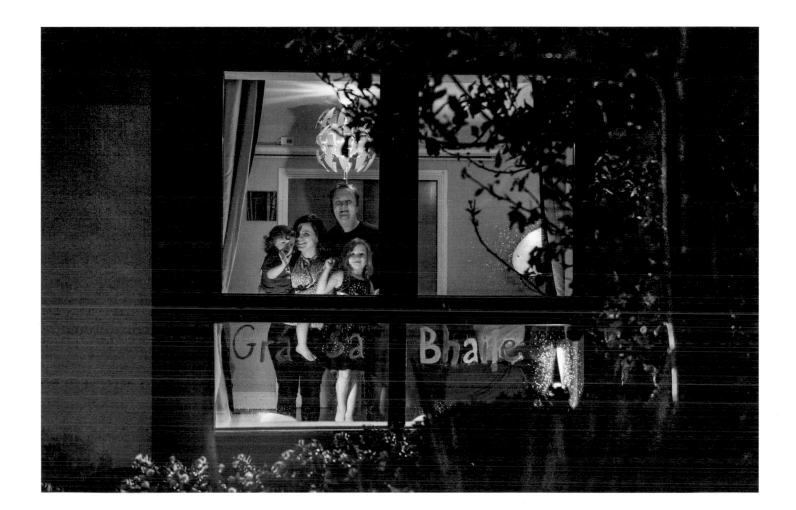

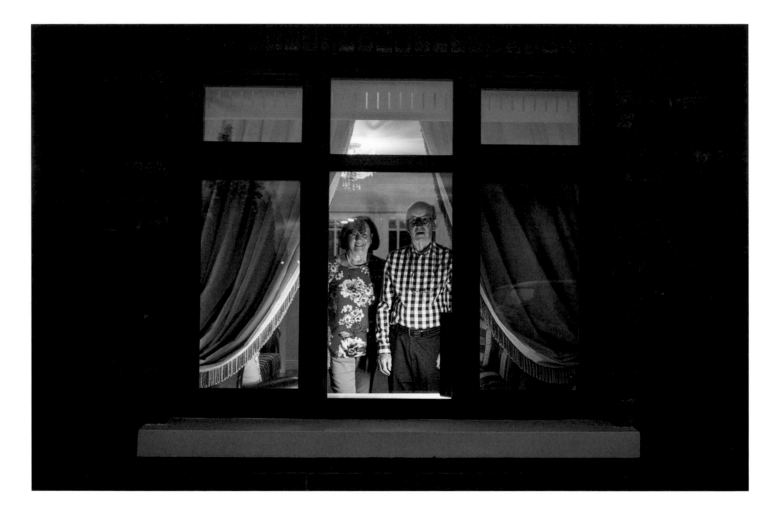

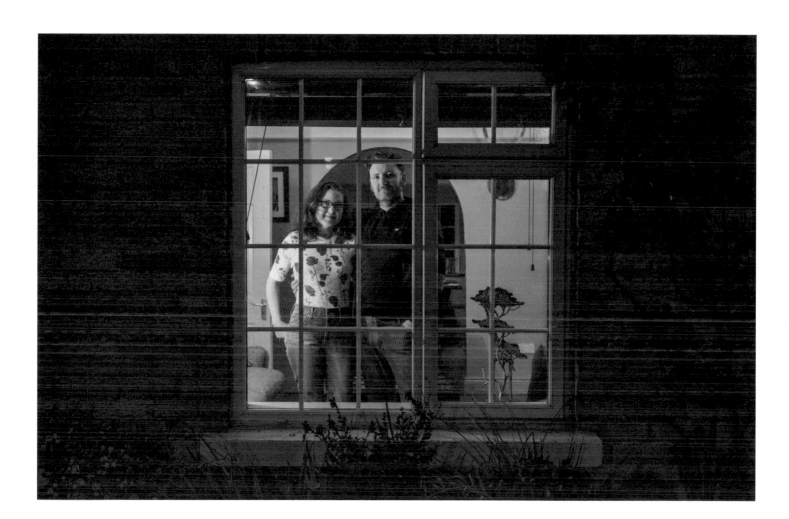

Hilary was due to celebrate the publication of her debut novel with a launch party in early March. Her son Peter, who works in London as an actor, flew home to attend. Unfortunately, Hilary's event was cancelled – as were those of so many other writers, playwrights, musicians, comedians and artists – and Peter found himself locked down in Dublin to weather the storm at home. At least he had his mother, a former actor, to help him run lines!

Hilary found new ways to meet her readers, via book-club Zooms, social media Q&As, virtual book festivals, and more. And, like other authors, she felt the unwavering support of the Irish book trade behind her. It won't be quite the same, but I'm hoping Hilary and Peter join me for the launch of *Twilight Together,* where we can raise a glass to rolling with the punches.

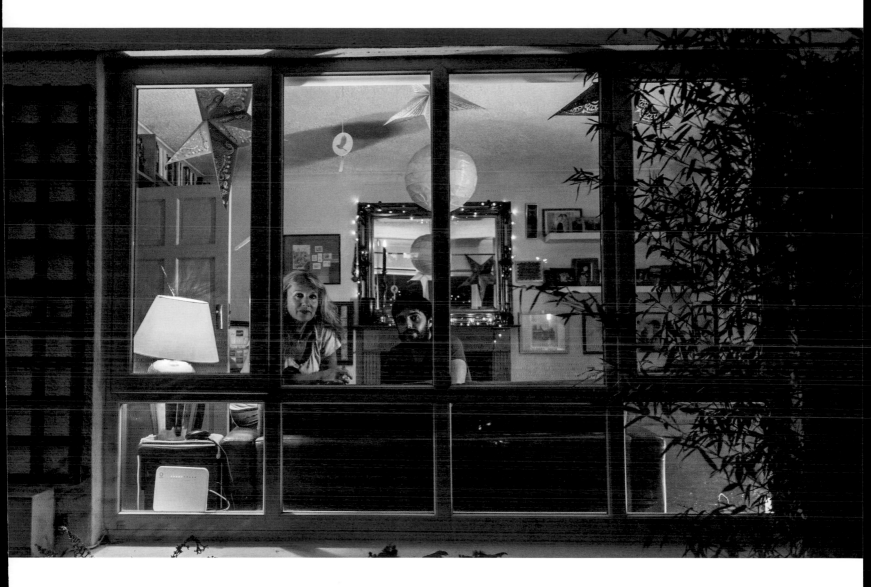

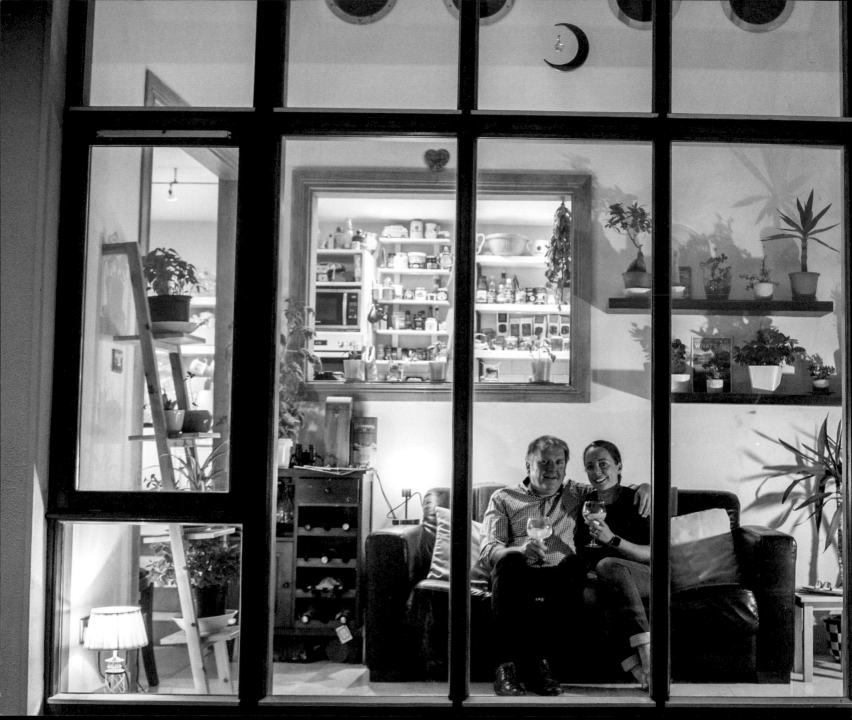

As the lead singer of Bell X1, Paul Noonan is well used to entertaining people all over the world from massive stages. During lockdown he became the saviour of many households by hosting sing-along sessions each week from his front room. These sing-alongs were designed not only for Bell X1 fans, but also for their children.

Accompanied by his own kids, Paul would serenade us with acoustic versions of classic songs and musical versions of traditional nursery rhymes. He's the most perfect example of people doing what they could to bring a little bit of light and happiness into the lives of others.

Parents who were exhausted from home schooling, in need of respite, could safely hand over their kids to Paul for an hour. I know I wasn't technically his key demographic, but I found myself grooving to 'Incy Wincy Spider' on more than one occasion.

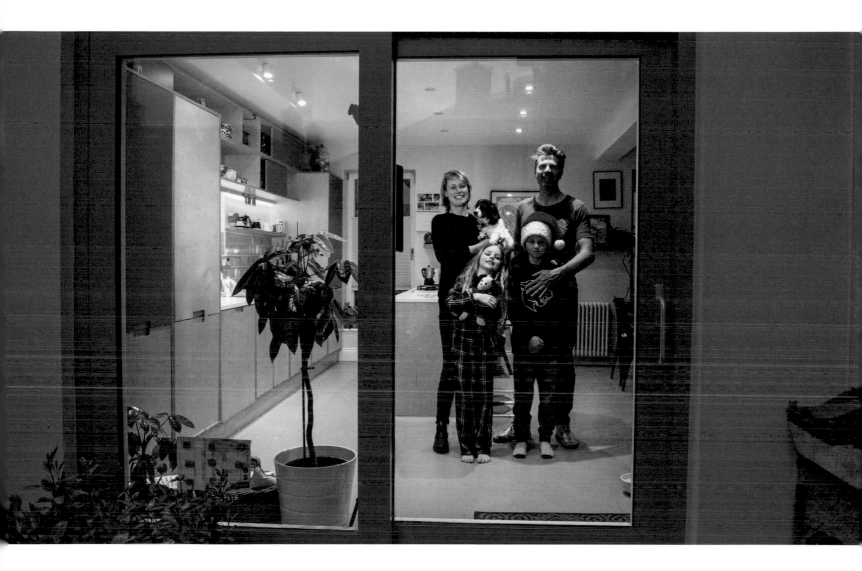

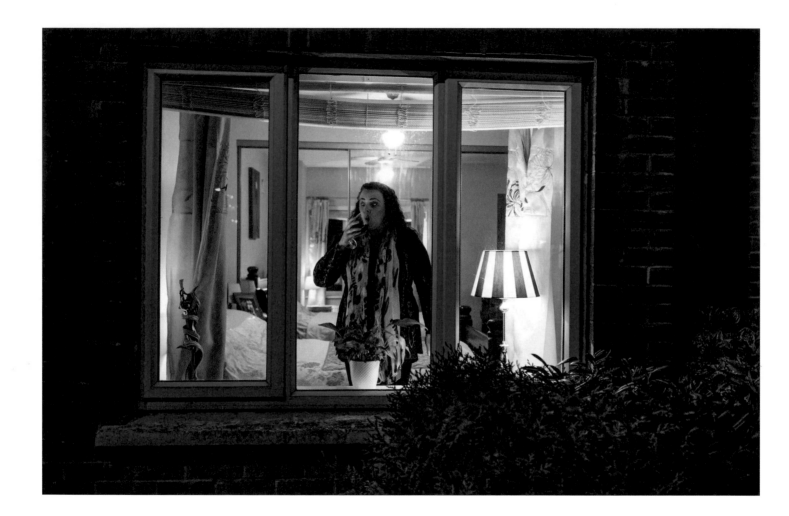

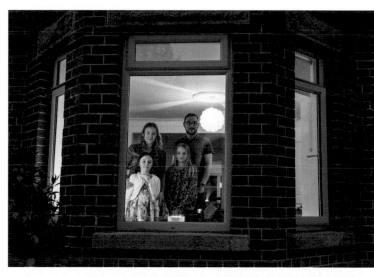

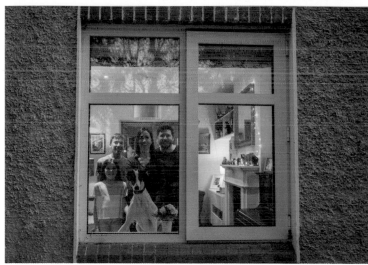

One of the hardest parts of this project was the travelling. I'm used to long and lonely drives for work, and usually I enjoy the quiet of the road. This trip was different from anything I'd ever done before, though, as there were no restaurants, pubs or cafés open. There was nowhere to stop – not even to use the loo!

I tried to plan by calling ahead to make sure the service stations were open, as the information online was never updated for Covid. I'd ask them if the toilets were going to be open and if their coffee machines worked. Usually, the answer to both was 'no'. Not only were the journeys long and arduous, but the return drive also had to be made on the same night. There were no B & Bs, and the only hotels open were out of my price range.

When people from Ardmore in Waterford heard of my upcoming trip to nearby Cork, they kindly offered me a place to stay. The generosity of the people I met during the course of this project never ceased to amaze me. My bed for the night was in a luxury glamping pod just outside of town. The glamping area was closed because of Covid restrictions, so I was the only person on site. The best part was that the pods were on the grounds of an open farm and mini-zoo, a big change from the busy housing estate in North Dublin that I'm used to.

Shortly after I arrived, I photographed Bridget, the owner of the site, with her family, which temporarily included Skippy the baby wallaby. Bridget obviously takes her work home with her. That night I fell fast asleep listening to the sounds of macaws and marmosets instead of the M50.

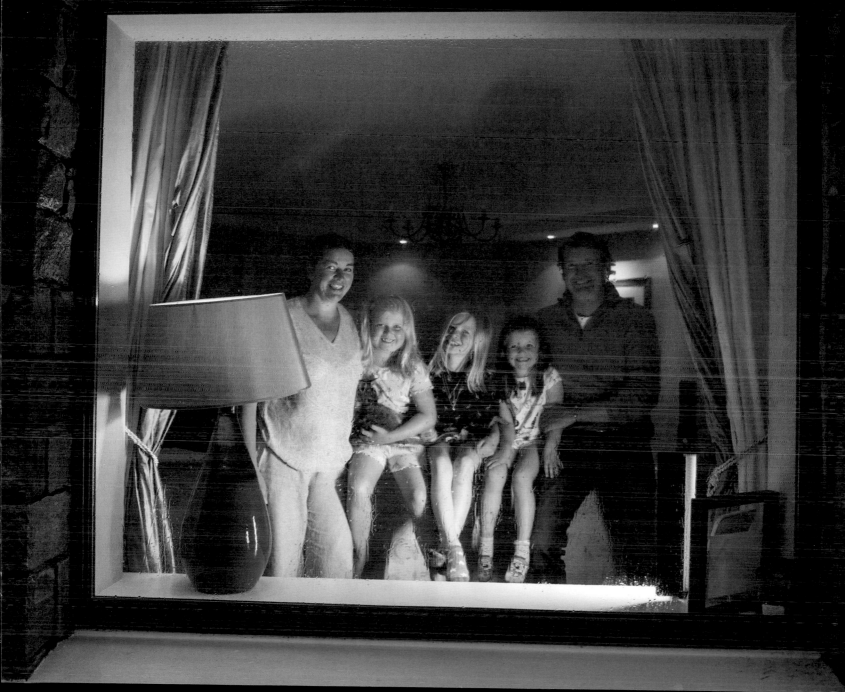

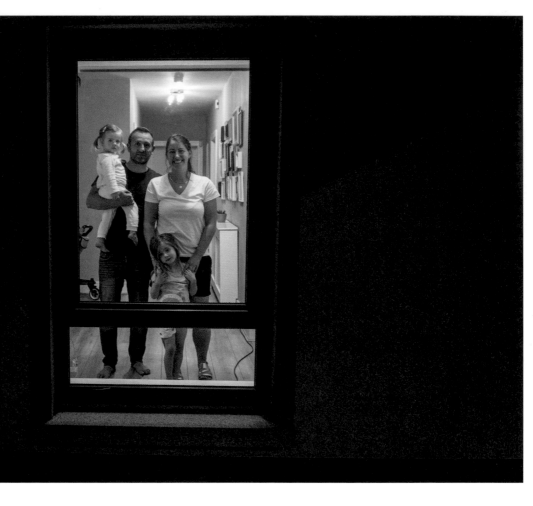

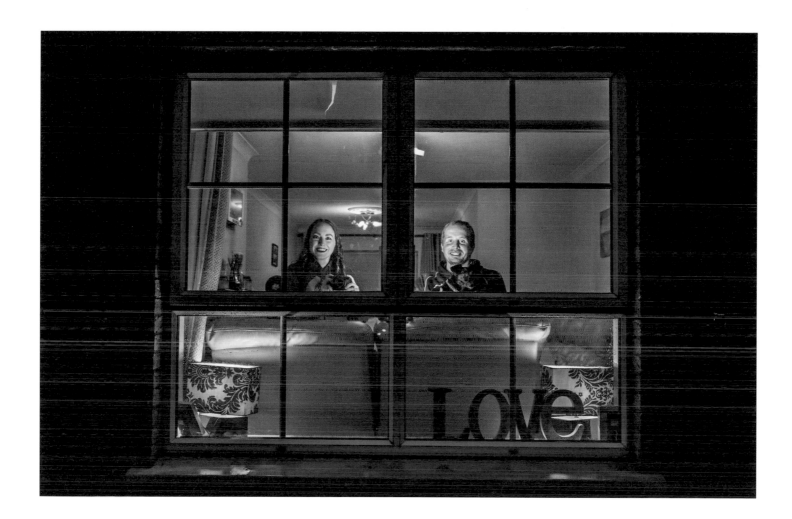

I know I won't be alone in saying this, but lockdown was probably the hardest time in my life. I had lost not only my job, but also the career I had been building for so many years – the very thing around which I had built my whole identity. I knew there were people much worse off than I was, but all I could see was what I had lost.

The sadness came in waves and nearly drowned me at times. But I was also surrounded by positive people who had more faith than I did. People who saw hope and promise in my work, and who helped me regain my confidence and sense of worth. These are the people who saw my little photography project as something much bigger than I could imagine.

Each time I'd post a photo online or the project appeared in the newspapers, I'd be flooded with encouraging messages from all types of people – my peers, strangers, book publishers, gallery curators, and friends of my mam's on Facebook. People were getting in touch to be a part of the project, and if they couldn't be in it they just wanted to cheer me along. It was these messages that kept me going and helped me continue to shoot night after night, even when I was exhausted.

The project taught me lots of things over the lockdown months but one of the greatest things I'll take away from it is the belief in the power of good vibes. It might sound cheesy, but when you put light and love out to the world, you get it back. Standing in front of those windows each night, I felt safe, even in my uncertainty, basking in the warm glow of their homes.

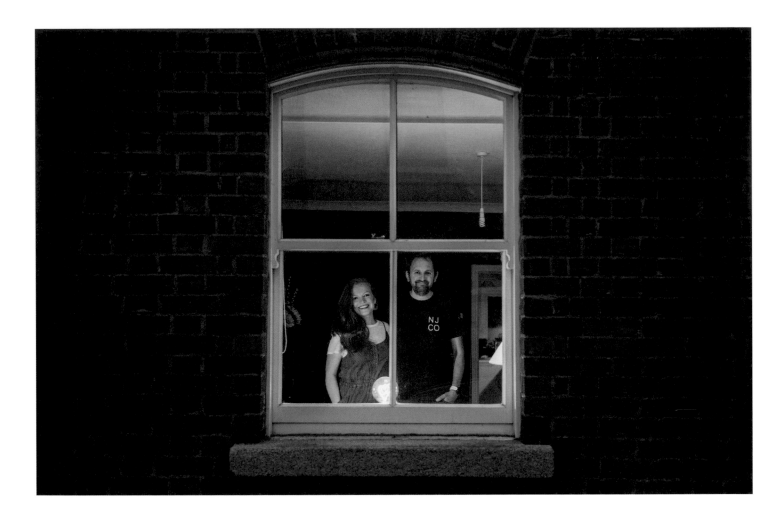

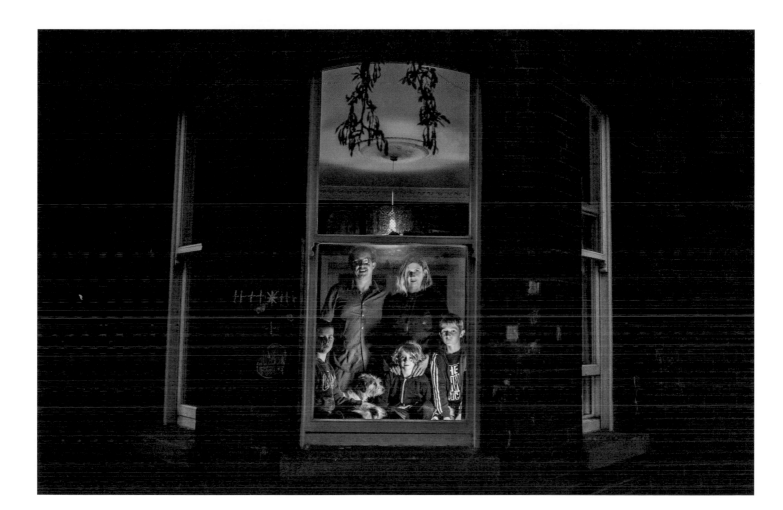

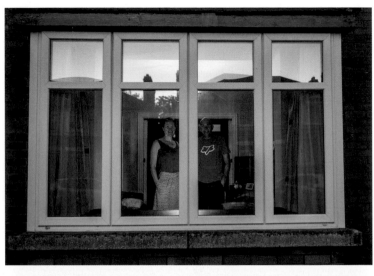
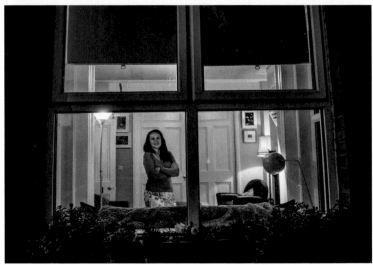

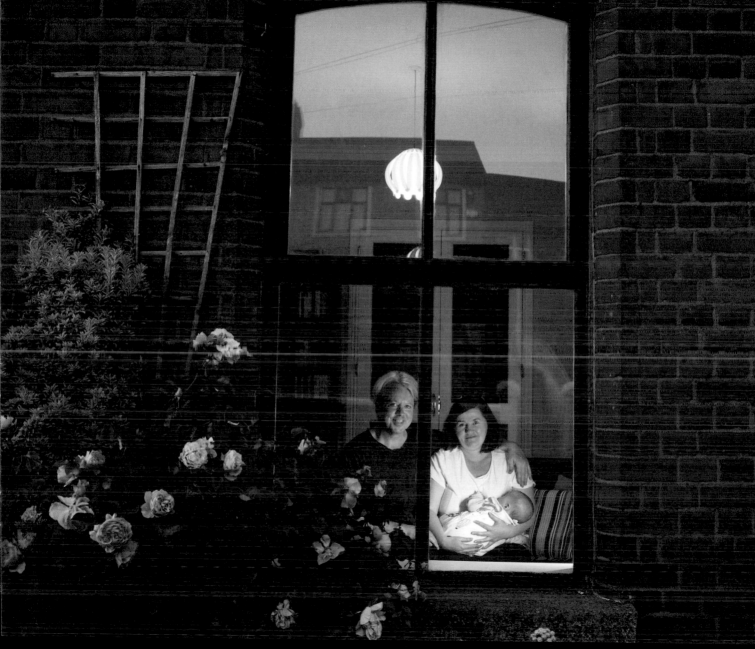

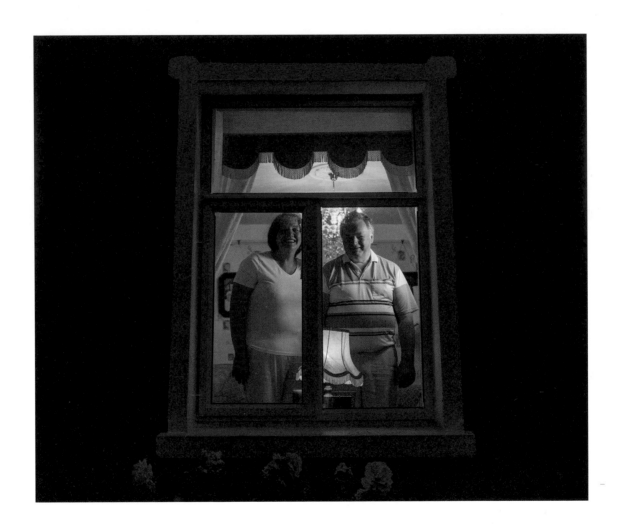

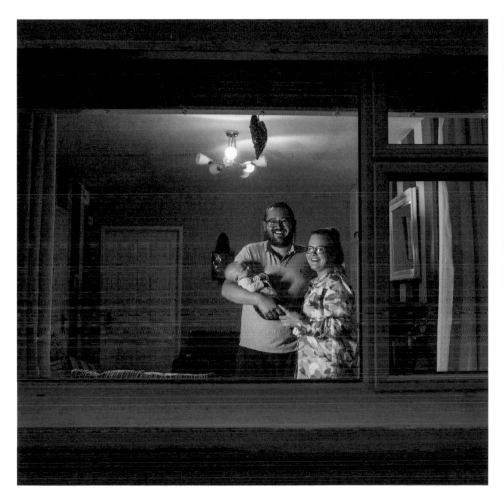

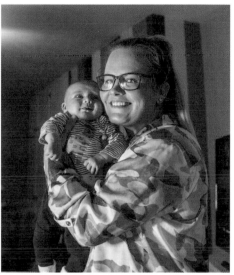

Tracy and Paudie with baby Paudie. 'This is how he has seen everyone his whole life – through the window.'

My next-door neighbours, Marian, John and Sara, are the heroes who got me through lockdown. Before the crisis, we would nod to one another and say a quick hello – always friendly – but we never had an excuse to go beyond that. In our estate, everyone tends to keep to themselves.

However, as the days rolled by and the pandemic grew more serious, our quick hellos turned into long, rambling conversations. That's how I found out I was living next door to total legends. We'd drag our chairs to the far end of our adjoining little patios and chat across the fence. We'd swap cakes and banana breads, and make lofty plans for our 'end of lockdown tiki party'.

On the weekends, a text would always arrive just after twilight, when they knew I'd be finishing up my shoot for the night: 'Cocktails out the back, ready when you are.' At a time when the distance between friends and family seemed so far, it turned out that my new nearest and dearest were just over the fence.

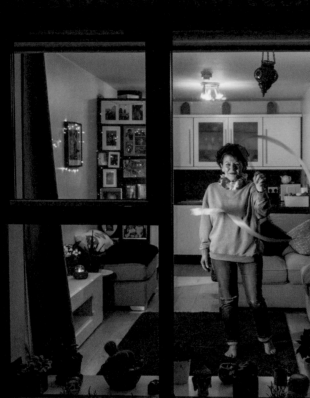

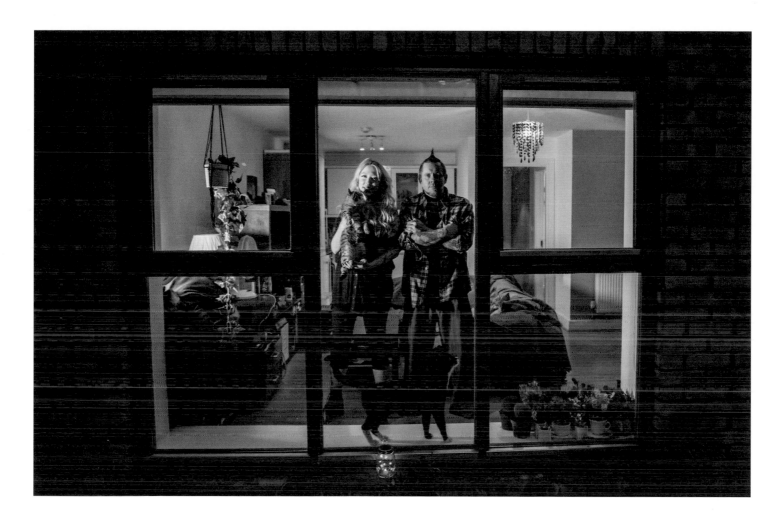

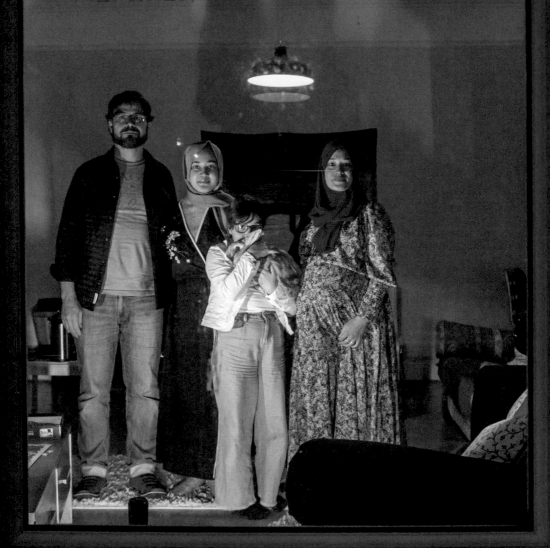

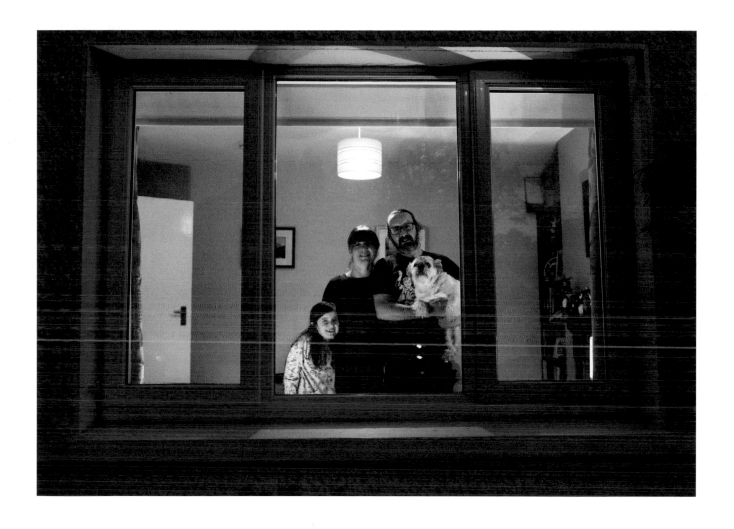

My friend Lorraine is the kindest spirit you'll ever meet. She started a job in a nursing home not long before Covid-19 hit, but long enough to forge some fantastic friendships. She'd constantly update me on what her favourite residents had been up to, and the stories they had shared with her.

Her nursing home was one of the most severely affected by Covid-19. Lorraine too became sick with the virus and was forced to spend weeks at home recovering and isolating, feeling guilty about not being able to comfort her new friends. When she did make it back to work, the atmosphere was quiet and different from before. As she hadn't been able to be with some of those friends when they died, she instead had to visit their graves to say a proper goodbye.

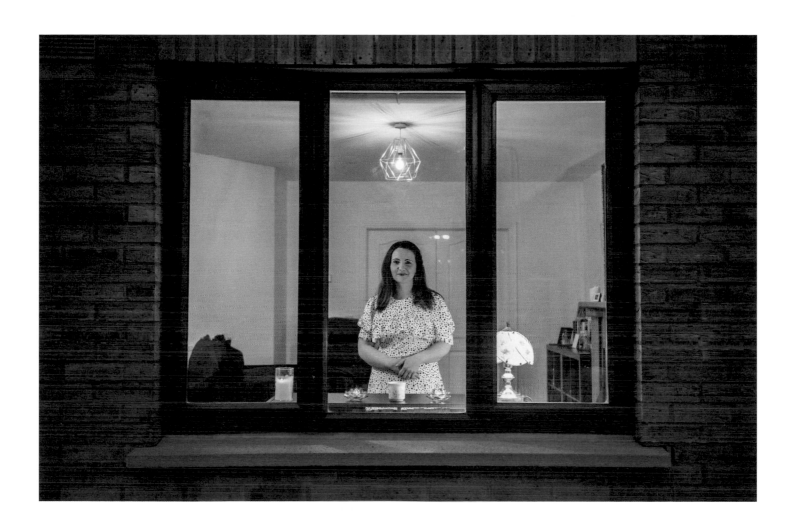

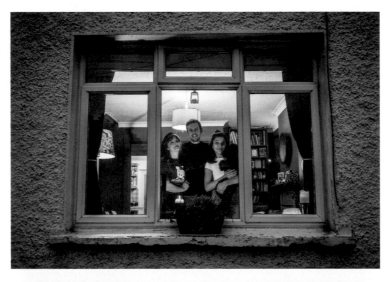

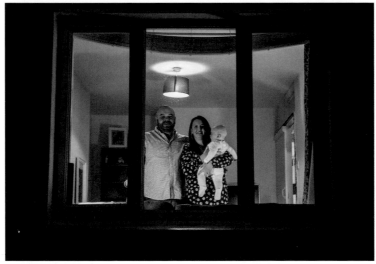

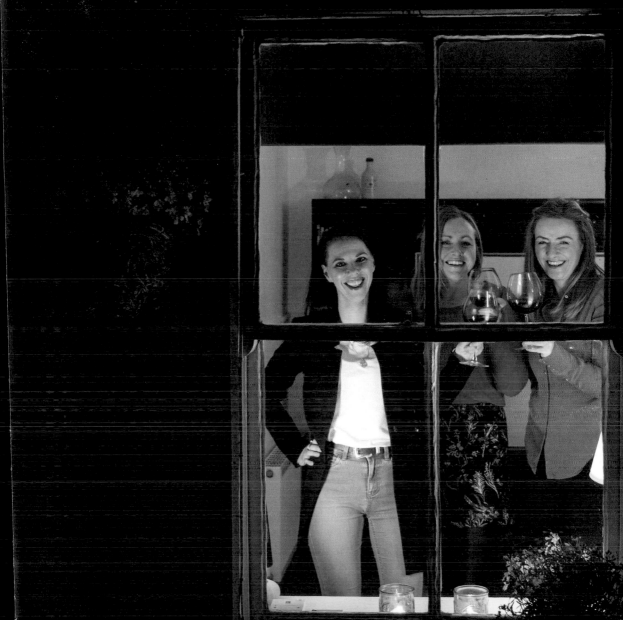

New Row is a magical little street in the heart of Dublin, where community spirit was more vibrant than ever during lockdown. I started my evening with three confirmed houses, but as neighbours saw what was happening, they all wanted to be involved. I moved quickly from house to house as people dashed around to clean their windowsills and weed their flowerpots. They threw bottles of window cleaner and J-cloths between them like jugglers.

Conor carried his kitchen chair up and down the street for me to stand on (New Row windows are surprisingly high) and Lorraine went a house ahead of me, prepping everyone so that they'd have their curtains open and the big light on when I arrived. People hopped in their cars to park and re-park so that I could get a clear shot of a neighbour's window. Everyone gathered round and watched as I photographed the family inside, and then would dash to the next house with me.

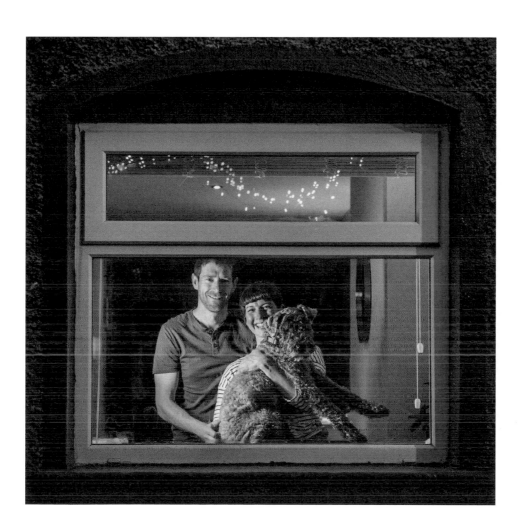

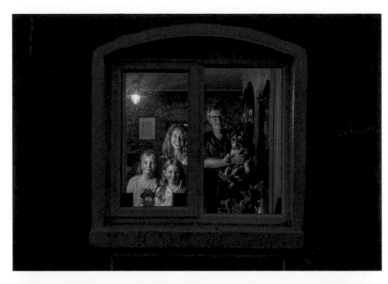

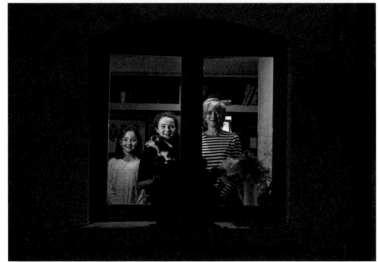

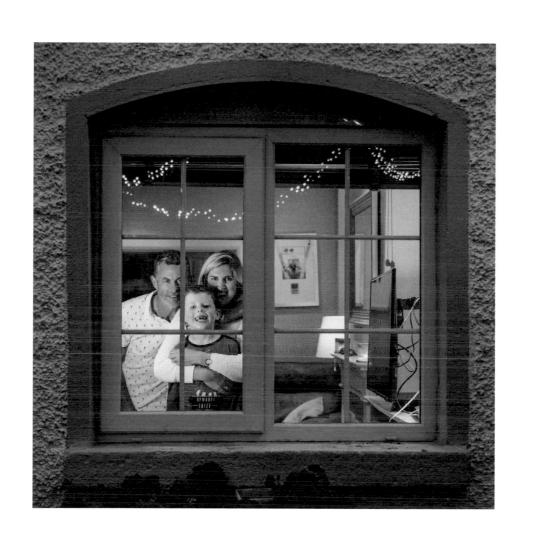

That night, before twilight faded, I managed to shoot a record number of windows. After the photos were done, everyone came together in the middle of the road for a drink and a socially distanced chat. Well, nearly everyone – Kobi opted to watch from the comfort of his own home.

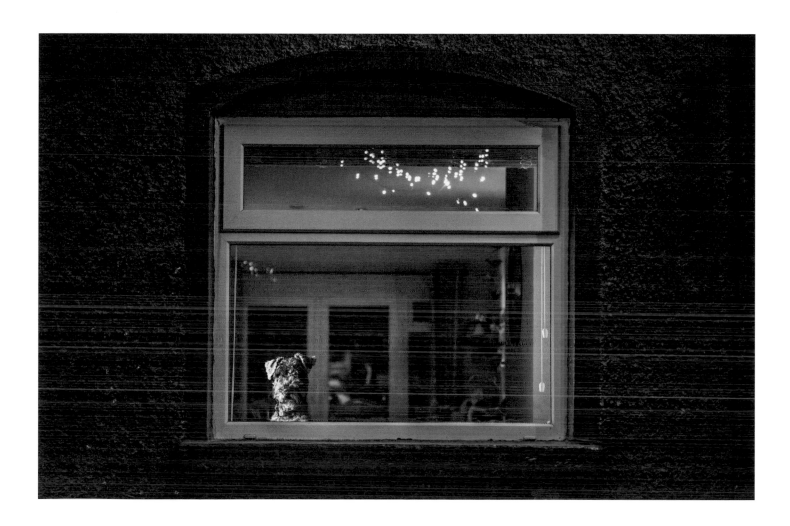

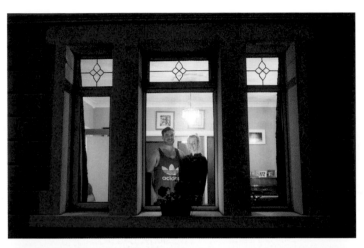
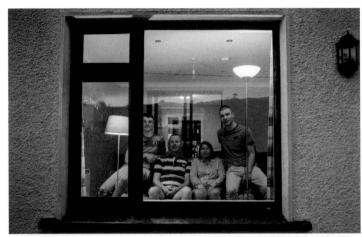
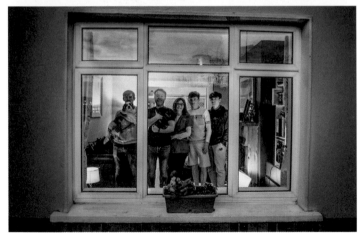
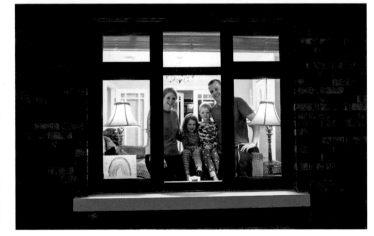

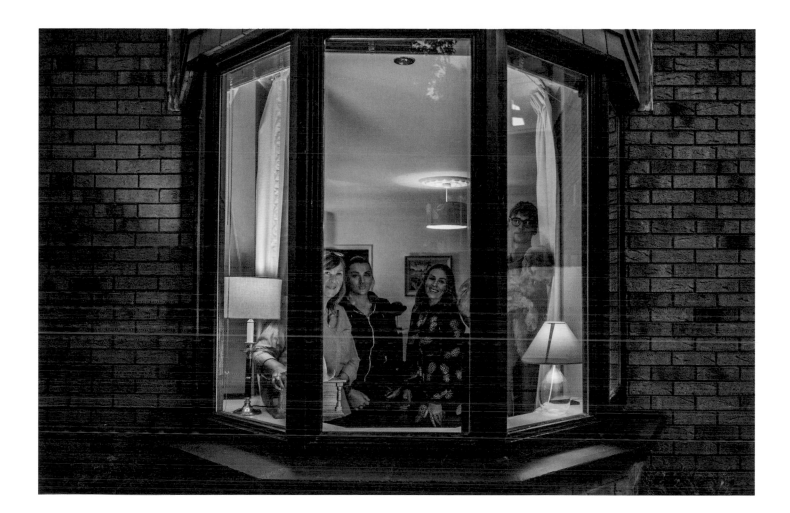

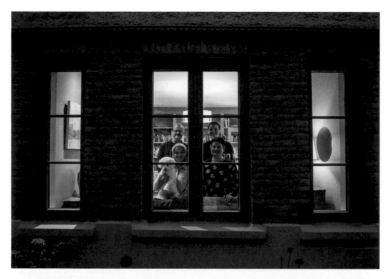

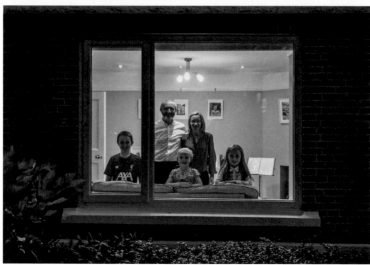

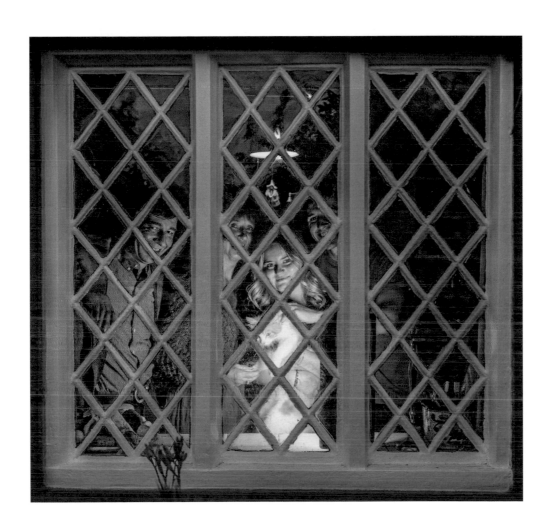

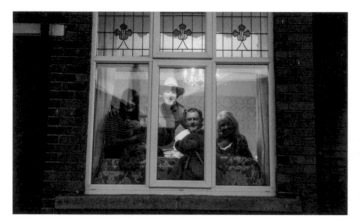

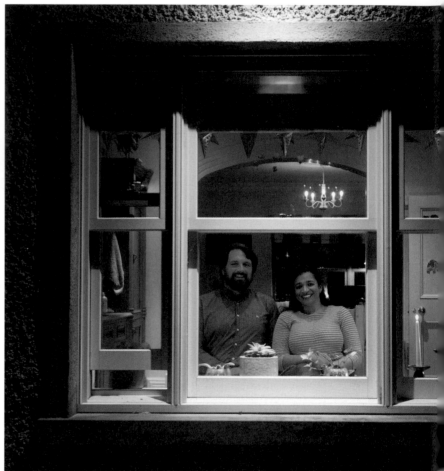

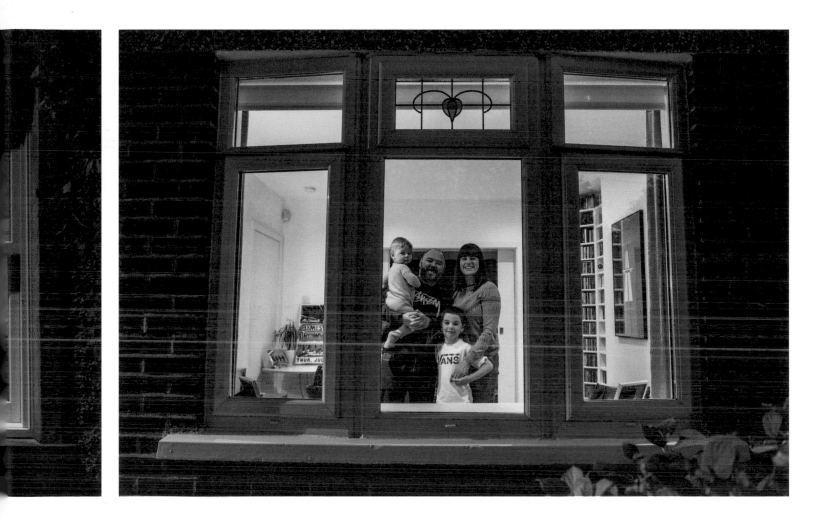

Sinéad White and I were travelling through Morocco in February when we first heard rumblings of Covid-19. It all became very real once we'd arrived home and lockdown began. Being a talented musician, Sinéad wrote and recorded an incredible song while isolating at home. 'The World Stops Spinning' became my Covid-19 anthem. I'd listen to it nightly as I made my window rounds. I'd linger over the lyrics, which felt so poignant, and the melody, which was hauntingly gorgeous. I felt as if she'd written it just for me, which is always the mark of a great song and an even greater songwriter.

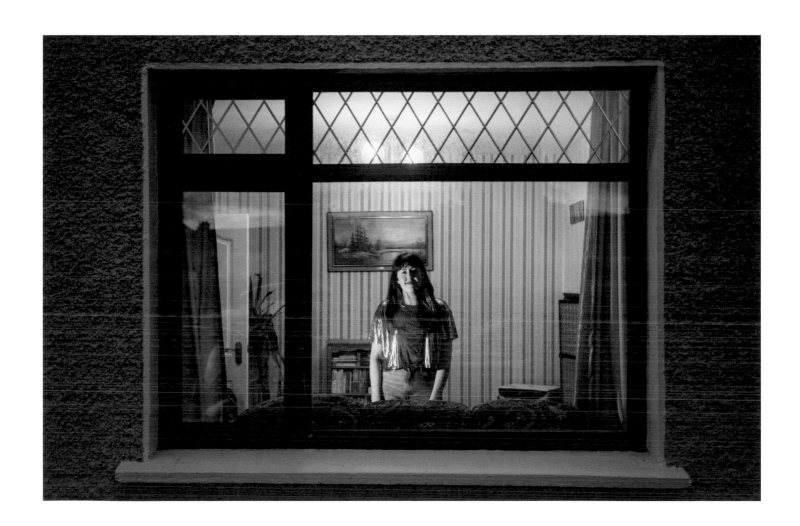

THE WORLD STOPS SPINNING

by Sinéad White

The world stops spinning,
For a moment,
I can breathe.

This feels like falling,
This feels like
The end.

The guards came,
Took my family.
Yeah, I love too much anyway.

This feels like drowning,
This feels like the beginning.

Keep your head up,
Keep your mind sharp,
Keep your hopes in check.

We're not broken,
Split right open,
It's not over yet.

My head got heavy,
My world got small,
I miss freedom most of all.

This feels like fading,
This feels like
Everything's changing.

Keep your head up,
Keep your mind sharp,
Keep your hopes in check.

We're not broken,
Split right open,
It's not over yet.

Don't you believe me,
When I'm bleedin',
When I'm asking why,

Cause we're not broken,
Split right open,
Time to look inside.

When I started out with this project, every night I would take my dog, Leia, with me for our walk. We'd stop only for a brief moment to take the photo, then off we'd go again to the next house. It was perfect for her – an extra daily walk and lots of new gardens to sniff. Once my journeys expanded to capture the length and breadth of Ireland, it meant that my poor little dog wasn't going to see much of me. I sent her to spend time with her dad, Dee, in her second home (the one with the bigger garden).

This portrait was shot on the night I finished all the photographs for this book. I had a notion of making Dee and Leia my last stop, taking a lovely picture of the two of them together, and then bringing her home with me. Do you know how hard it is to get a 37-kilogram dog to pose for a photo at the best of times, let alone when she hasn't seen you in months? Poor Dee nearly threw his back out trying to contain her, but we got the perfect shot in the end.

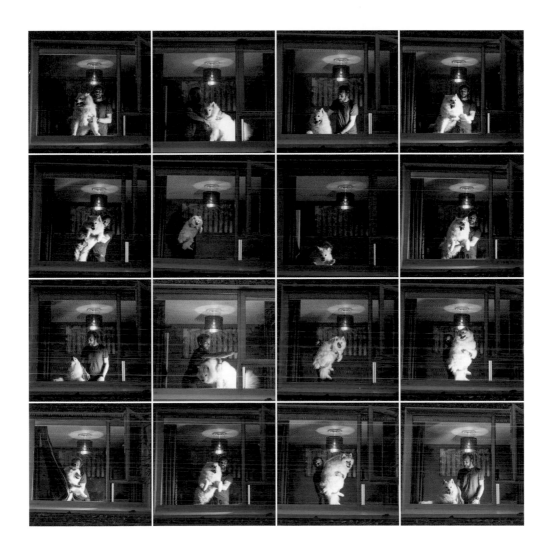

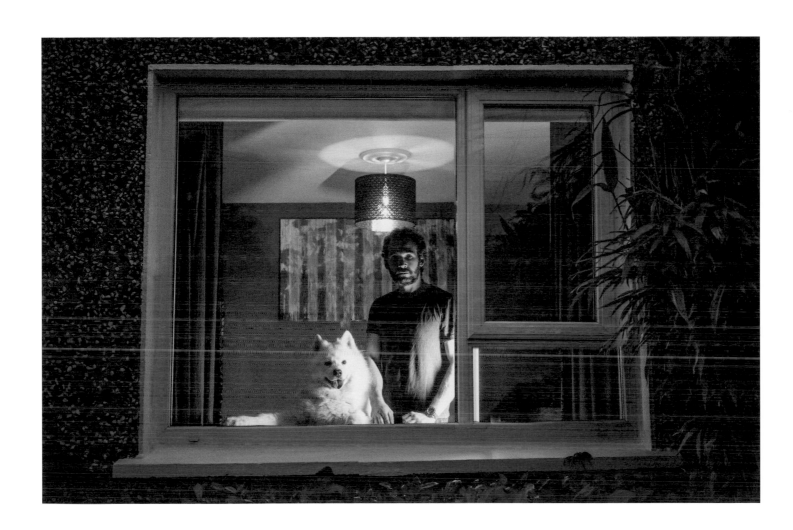

I visited 150 homes during the course of this project, and it felt right to end the journey back in my home with my dog by my side. I'm lucky to have all that I have, I know that. When taking this photo I suddenly felt a great sense of panic. I was aware of all the people who would now see into my home, a previously private space; that curious minds would naturally wonder about my choice of decor, the art on my walls and the size of my rooms. Am I what people expected? Is what I'm wearing 'photographer' enough?

Did I put the other 149 households through this same anxiety? I can't thank each and every one of them enough. They opened up their world to me, and they trusted me to portray them in a kind, decent and truthful light. I can only hope that I didn't let them down.

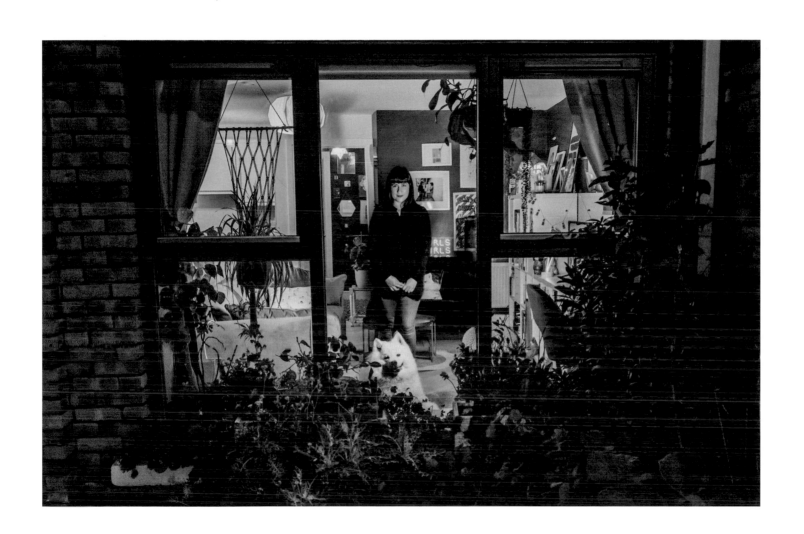

ACKNOWLEDGEMENTS

A lot of people helped to bring this book together, with special thanks to:

Joe in Offaly, Teresa in Ardmore, Michael and Margaret in Waterford, Kritika in Kilkenny, and Karen in Clontarf for introducing me to your friends.

Aoife McElwain for keeping me mindful, present and well fed in Clifden and beyond.

Joe Clarke for working on this, the first of many books I hope we'll do together.

Seán, for taking my photo.

Dee, for being there for Babygrrrl.

Lucy, John and Ryker for the future good times we'll spend together.

Sinéad White and Stephen James Smith, for lending me their beautifully crafted words in this book.

Fiona Murphy, for being the first person to have faith in me, not only as a photographer, but also as a writer, and for always saying, 'This is your book.'

Tina and Moh, for everything, always.

Dublin-born music and portrait photographer Ruth Medjber holds a BA (Photography) from DIT, and her work has appeared in *Hot Press*, *NME*, *Rolling Stone*, *Kerrang!* and *Q Magazine*. Medjber's portfolio includes photographs of Grace Jones, Beyoncé, Metallica, Billie Eilish and the Foo Fighters. Most recently, she documented Arcade Fire and Hozier on their tours of the UK and Europe, as well as covering the Glastonbury Festival for the BBC. With close ties to her community, she uses her creative talent to support local charitable causes and has a long-term project *Women of Notes*, which celebrates inspiring women in the Irish music industry in a bid to create a gender balance in music.

www.ruthmedjber.com
@ruthlessimagery